BOLD VISIONS

THE DIGITAL PAINTING BIBLE

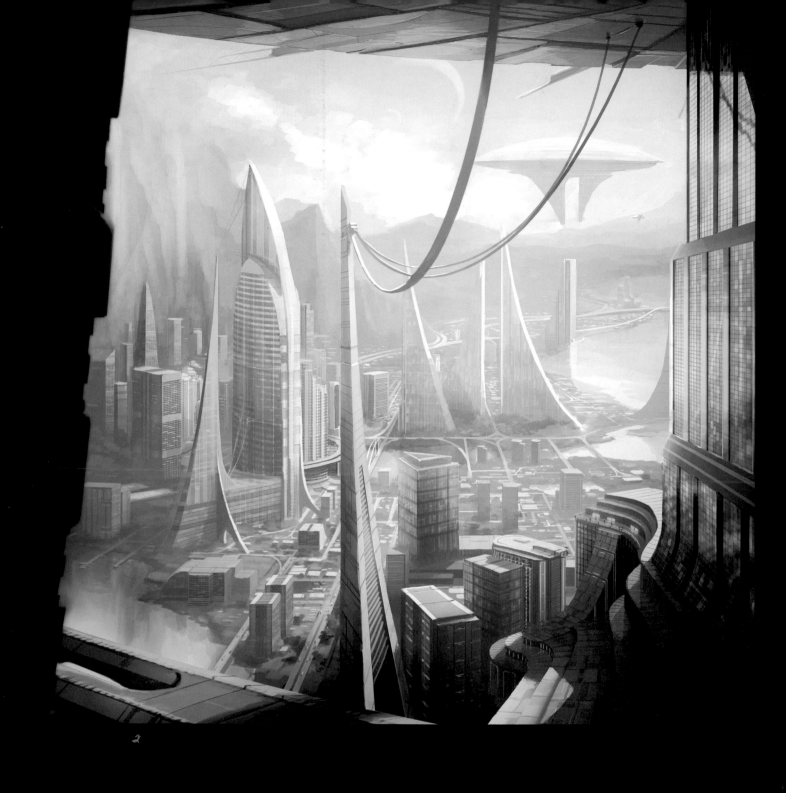

IMPACT

BOLD VISIONS
THE DIGITAL PAINTING BIBLE
FOR FANTASY AND SCIENCE-FICTION ARTISTS

GARY TONGE

776
Tonge

17.99

Davidson

DC 11

**To my daughter Catherine,
light of my life.**

A DAVID & CHARLES BOOK
Copyright © David & Charles Limited 2008

David & Charles is an F+W Publications Inc. company
4700 East Galbraith Road
Cincinnati, OH 45236

First published in the UK in 2008
First published in the US in 2008

Text and illustrations copyright © Gary Tonge 2008
except those acknowledged on page 128.

A catalogue record for this book is available from the British Library.

ISBN-13: 978-1-6006-1-020-2 paperback
ISBN-10: 1-6006-1-020-X paperback

Printed in China by SNP Leefung Co PTE Ltd
for David & Charles
Brunel House, Newton Abbot, Devon

Senior Commissioning Editor: Freya Dangerfield
Editorial Manager: Emily Pitcher
Project Editor: Ame Verso
Desk Editor: Demelza Hookway
Art Editor: Martin Smith
Production Controller: Kelly Smith

Visit our website at www.davidandcharles.co.uk

David & Charles books are available from all good bookshops;
alternatively you can contact our Orderline on 0870 9908222 or write
to us at FREEPOST EX2 110, D&C Direct, Newton Abbot, TQ12 4ZZ
(no stamp required UK only); US customers call 800-289-0963 and
Canadian customers call 800-840-5220.

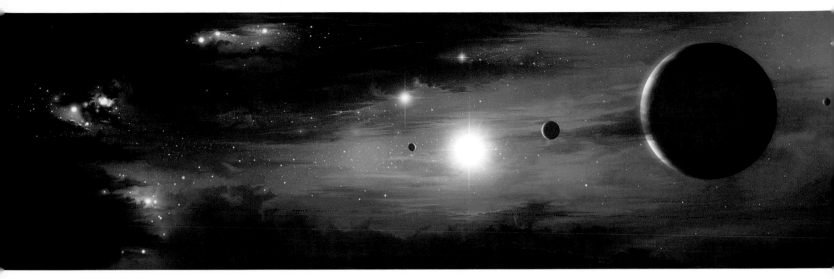

SYSTEM BIRTH An alignment of celestial bodies orbiting in a young solar system.

CONTENTS

INTRODUCTION

Welcome to *Bold Visions*, *The Digital Painting Bible*. I am Gary Tonge, a professional digital artist with experience dating back to 1987, when I jumped head-first into the computer software industry as a games artist straight from school. During this time, I have seen computers transform from simple game-playing machines with very basic amateur painting packages on them, to become cutting-edge platforms for producing art of all kinds, surpassing traditional art in many ways, most importantly in the areas of speed and creative freedom. Over the years, I have oscillated through many fields of computer-aided art; from simple two-colour, sprite-based games software, through ultra high-end 3D modelling, animation and rendering, the 3D gaming revolution and all the way back to painting again, with tools that were beyond my wildest dreams when I started my professional journey. Many, many things have changed in the last 20 years in terms of how I do my job, but one thing that has remained constant is the thrill of creating powerful art. There is something quite amazing about being able to sit back and look at a vision that was once in my mind, and is now out there for everybody else to see. This is the key thing I hope you gain from reading this book; to galvanize your ability to translate what you see in your mind's eye into something that other people can appreciate – not only for its artistic merit, but also for the unique nature of what you have created.

In this book you will find a diverse selection of images, mostly painted by me, but with a few choice examples from other artists too, which I hope you will find inspiring. The chapters are designed to help you understand the creative process undertaken to create these paintings, as well as the decisions that were made during their development. I also offer some handy tips on techniques that I use in my work. Along with these tutorials you will find a number of sections about how to explore and utilize Adobe Photoshop in your own way, with explanations on how many of the program's powerful tools operate.

It is my hope that you will find a new zeal for your artistic endeavours after reading this book, whether your goals are simply to improve your skills to help make your hobby more enjoyable, to really hone your proficiency in Photoshop, or even if you are looking to find a vocation as a professional artist. The journey is about to begin – are you ready?

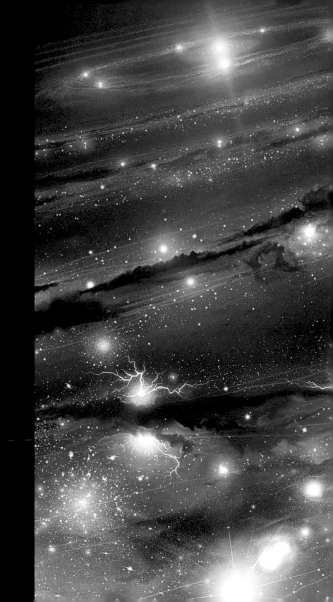

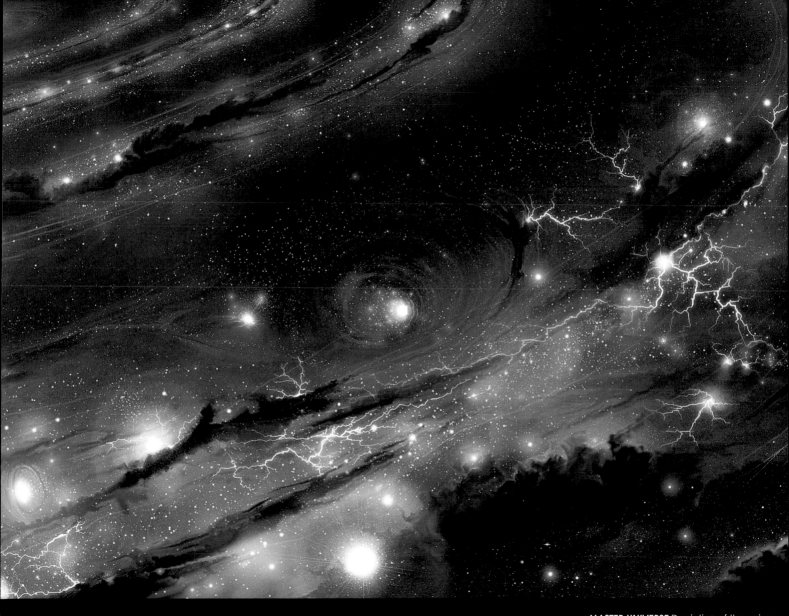

MASTER UNIVERSE Depiction of the universe.

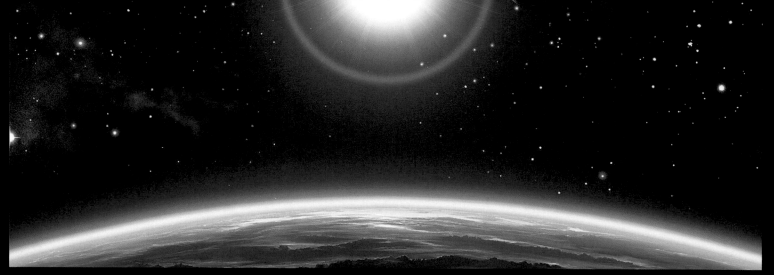

REACHING OUT (crop) A distant world.

Materials

All artists need certain things to get the job done, whether that is a wall-sized canvas and 24 tins of acrylic, or a 3Ghz computer with a 24in monitor. The important thing is making sure that whatever you think you might need to be creative is in place, so you can lock the doors, put the coffee on and paint until the morning light.

DIGITAL TOOLS

The phrase 'the artist's studio' used to conjure up an image of rough wooden floors, simple white walls with splatters of paint on them, a pile of canvases – some clean, others finished or abandoned – and a myriad of painting materials, brushes and inspirational objects. The studio needed ideal light to work in, so a large window and good lighting would be essential.

The digital art studio is somewhat different – all the paint and canvases you are ever going to need are stored in the computer – but there are a lot of other tools that are useful to help artists create visions with greater control and ease. Essentially, these tools are all here to make digital art as fluid as it can be and as close to the original medium as possible.

I prefer the feeling of working digitally to working with real paint; it means I don't have to refill my brush while I paint, and I have the ability to change and save my work quickly. Here, I've laid out how my studio looks, based on a photograph. I have depicted how I situate most of the digital tools I use, as well as some other useful items to consider having in your own studio space.

SCRIBBLE PAPER: Very useful to have handy, so you can quickly play with ideas and take a break from the screen at the same time.

MONITOR: Always purchase the best quality screen you can afford, as you will be looking at it a lot. I prefer 16:9 (widescreen) monitors rather than the standard aspect ratio screens.

SPEAKERS: When you are burning the midnight oil, it is nice to have some music playing.

MOUSE: I tend to use the mouse provided with the tablet, but if I am working in 3D I will use an optical mouse for greater precision.

WINDOW: It is great if you can have a studio with a good view; if not, try to have natural light coming in and effective blinds if you want to block it out.

HIGH-SPEED MODEM: Imperative for working digitally. High-speed connections make it possible to send large bodies of work to clients, and to web-research any items needed for a project.

GRAPHICS TABLET: This should be positioned so you can easily reach it, allowing for easy hand movement over the entire tablet area. 16:9 tablets are now available.

REFERENCE MATERIALS: Relevant to what you are working on at the current time.

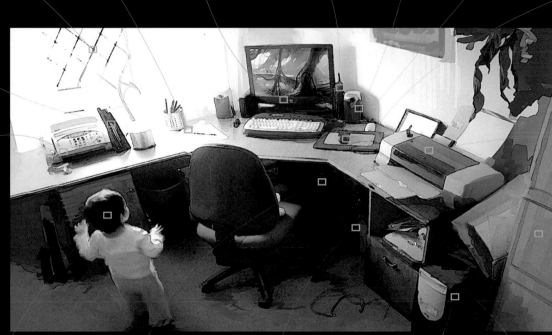

PRINTER: If you are looking to print your own work, try to get a good-quality large-format photo printer.

PHONE/FAX: Used to shout at your ISP if the broadband goes down in the middle of a large upload, or to send contracts to clients and so on.

FILING: I admit I am terrible at keeping track of things, but filing is very important when you are dealing with a lot of different projects at once.

SOFTWARE: Autodesk Maya and Adobe Photoshop boxes are stored under my feet, in case I need to refer to the instructions.

COMPUTER: The heart of the digital art system. My machine is quite noisy, so I put it on the floor and under some other things.

SCANNER: Tucked away under the main desk area to save space.

LITTLE MONKEY/MINI-ME/INSPIRATION: More of a hindrance than a help in most cases, but cute nonetheless and my very reason for working (to keep her in cuddly toys – she has just put one on Daddy's chair).

CAMERA: The case is under my desk so I can find it quickly. I'm holding the camera to take this photo and the USB lead is lying on the floor ready to upload the image.

WORKING WITH COMPUTERS

Working with computers to create art has many advantages. The ability to 'undo' something if it goes wrong is the first one many people think of, but there are many other things that I am enormously thankful for when working on paintings using the computer. Layering, history, and the ability to save a piece and then go *wild* with it if I want to try something new or dangerous are all functions that I would sorely miss if I were to return to working traditionally. That being said, there are a number of elements to digital art that require careful setting up and monitoring. These things are fairly easy to get to grips with, but it is important that you keep up to date with them so as to avoid your work being damaged, drawn incorrectly or, worst of all, lost totally.

ARRANGING YOUR WORKSTATION

Try to make sure that you have a good-quality seat that is well positioned in relation to your workstation. It is easy to get so locked into a painting that you can be there all night, so ensure that you are comfortable and not in pain afterwards. Make sure the monitor is positioned so you do not find yourself stooping down or craning your neck up to see it, as this will make working for prolonged periods very hard. Position your tablet and mouse so they fall into your hands easily, too – these are your connection to the screen and therefore your painting. If you are serious about using your computer to create great art, getting these things right will make it much more relaxing.

MONITOR CALIBRATION

This is a very important part of working in the digital medium. The monitor is your window into the digital realm and if it is set up incorrectly it is as bad as not washing the windscreen on a car – you can't see things properly. There are a few aspects that can be out with the display (although these have been greatly reduced with the new digital output graphics cards and monitors available recently). The temperature of the screen can be incorrectly balanced, causing white to look too yellow or too blue, for instance. Just as important, the gamma of the monitor can be wrong, and this can cause all sorts of problems if you are painting using a badly calibrated system. Wrongly set gamma can cause what you paint to look very bright or very dark and oddly shaded to people with correct calibration. Use the Adobe Gamma settings, or a web-based guide, to ensure your system is correctly set up before you start painting.

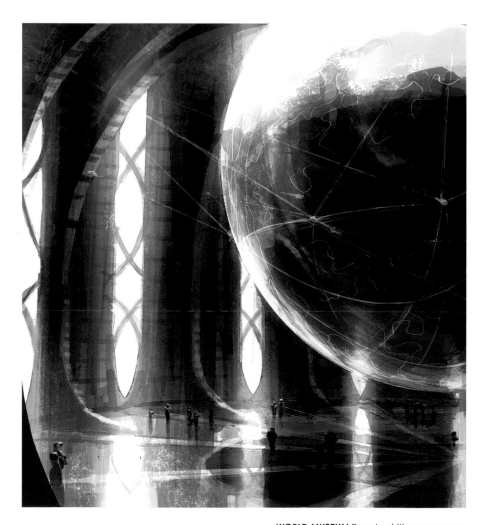

WORLD MUSEUM People visiting a museum where scaled functioning copies of planets are suspended from the vaulted roofs.

SAVING WORK

I am a bit of a worrier – I tend to imagine that things might go wrong and that affects how I save my work and how often. Obviously, it is important to save the work you have created, otherwise it will be lost, but I tend to save my work sequentially, at each important stage of its development. This is very useful for when you come to show people how you created an image – as in this book – but it is also a very good way to save parts of the piece that you might want to retrieve at a later date, or to look back and see the direction you took with the piece as it progressed. I know that it might seem better to store historical elements and old features on an invisible layer, but working at very high resolutions requires keeping the layers (and therefore the file size) down to a minimum, so I tend to leave these things in the legacy files. The most important thing to remember is to save often – you never know when a program might crash or when there might be a power cut.

MANAGING YOUR FILES

I save my images with sequential file names (e.g. Tower_01.PSD), but I would recommend that you also create directories for each image as it is created. If you start a new folder, you can drop in your sketches during the concept phase, any scanned-in pencil images you are using and photo references too. These can then be cross-referenced quickly without worrying about other projects cluttering up the place. The reason I say this is because in the past I have been quite messy with my file usage – and believe me, it gets very out of hand when you have a large body of work, all with iterative steps, concepts and ideas sitting in just a couple of directories. Try to keep things neat; it is much better in the long run.

BACKING UP

Whatever you do, always make sure you have a fairly recent back-up of your work. When working digitally you do not technically have an 'original' piece of art – it is just a string of data that can be damaged, or lost completely, if you have a hard drive crash. I recommend purchasing a removable USB drive of reasonable size so you can back up your files every couple of weeks at least. I have been on the receiving end of a crash or two, in one case losing a lot of work and about 3,000 emails. Also, think about getting a 'snapshot' of your work backed up permanently once or twice a year, just in case you delete files that a couple of years down the line you think you might like to revisit.

AZURIAN CORE A blue-white star emanates light as the gases and dust around it congregate into new worlds.

SOFTWARE

Computers are amazing devices, capable of ever-greater speed and graphic detail, but to most of us they are only invaluable because of the software that is developed for them. It is fair to say that the wave of digital art that has grown in the last two decades would be just a ripple without the dedication of the engineers and artists who develop software that is intuitive, powerful, fast and reliable. Of the software currently available, I tend to focus most of my time inside one program, Adobe Photoshop (currently version CS3). However, there are other great tools out there for artists to work with, so here I explore the major programs that you might come into contact with. I am certain you will have your own favourites, or may even prefer moving between different programs as you work.

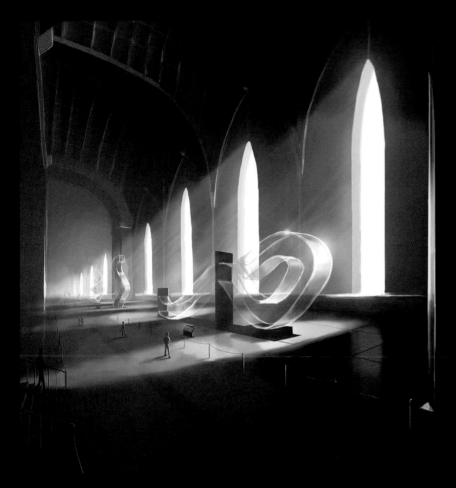

GALLERY An arcade of immense crystal sculptures set in an enormous building. Photoshop is great for working up images that require careful control over colours, effects and atmosphere – this rough image is a good example.

ADOBE PHOTOSHOP

I thoroughly enjoy working with Photoshop, although I was somewhat late to come to it, starting with version 3 in 1997. Until then I had hung on to my old Amiga 500 and Deluxe Paint, but once I had seen Photoshop in action I soon moved across for all my illustrative needs. Photoshop, originally created by Thomas and John Knoll, was released on the Apple Mac only in 1990 and was not released as a PC application until version 3 towards the end of 1994. It has progressively become a brilliantly complete painting and image-editing package, so much so that many of the tools available in the later versions do not need to be used by everybody; rather, each individual has enough scope in the package to learn about it in a way that suits them. Photoshop is flexible enough to allow you to create the same effect or look in many different ways. This is one of the key facets I like so much about it: you can speak to ten different artists about the same effect or image and you will get a different technique for how to create it from each one – that's how versatile it is.

Of the many tools Photoshop has, I find the layering modes, brush controls, colour alteration and history functions most useful. Photoshop (more so than the major competitor Corel Painter – see right) has the most powerful array of image-editing and colour-tweaking tools, allowing practically anything to be done to an image. In fact, many of the Painter aficionados I know will move into Photoshop to do their colour tweaks and then back out again into Painter to continue afterwards. There are many other tools in Photoshop that I use (see Basic Techniques, pages 18–31), but the important thing is that it is a very easy program to use. Tools do not get in the way, but are quick to find when you do need them. I would say I know 99 per cent of Photoshop well, having read the manual only a handful of times in ten years, so it is very intuitive too.

FIRE AND LIGHT A study into aggressive tones and colours with loose brushstrokes. Painter is excellent for giving the artist visceral and realistic brush control, useful for speed paintings such as this.

COREL PAINTER

Painter differs from Photoshop in a number of ways, most notably the way the brushes and colours are controlled. Corel has gone to great lengths to make Painter feel very 'organic' as a painting system: the brushes can be easily set so they behave like actual brushes; the paint peters out as you prolong a stroke and there are also some exceptional bristle, pastel and other brush types and shapes to choose from. Also, colour mixes in a realistic way as you brush past one colour with another tone. Although I personally prefer Photoshop, I would say on balance that Painter has the edge for a 'real' painting experience. The rotate canvas function in Painter is also a boon, allowing you to spin the canvas around to get the angle you like to draw each shape better. For anybody who is looking to move from traditional illustration into digital, I would say the jump to Painter is a less intimidating and more natural experience. Interestingly, Painter and Photoshop complement each other well, almost as though it were intentional.

3D MODELLING PACKAGES

About 15 years ago, I was heavily involved with high-end modelling, animation and rendering using SGI Systems, working at what was, at the time, the cutting edge of visual effects. I used to absolutely love creating forms and environments in 3D and seeing them come to life through materials, lighting and rendering techniques. After a while, though, it became apparent that to keep creating this radical look was taking more and more time and I finally dropped back into illustration as a way of keeping the ideas flowing more fluidly. That being said, 3D packages such as Autodesk Maya and 3D Studio Max can be invaluable for solving problems in the conceptual phase of an illustration, or even for laying out difficult compositions, and I still use these in my current role to help speed up the process. Again, much like the Photoshop/Painter fans, people have different tastes when it comes to 3D packages. I have always preferred Maya – is it is an amalgamation of the software I used in the 1990s – but many people prefer Max. The choice is yours. However, these pieces of software are quite expensive, so do try them out rigorously before you commit to buying.

Block model render for the image *Radiance* (see pages 36–7 for final image). Building shapes and laying out compositions in 3D can save you time and a lot of headaches.

THE ELEMENTS
OF A DIGITAL PAINTING

When creating a digital painting, it is possible to draw on many different design sources. Using 3D shapes, pencil sketches and photographs that are scanned in, you can build up the layers of an image to give it maximum impact. This sci-fi image, *Arrival*, was created using the following elements.

A **simple digital wash** establishes the basic composition of the piece, the gentle arc of the planet's horizon from orbit and the rough colours that will be used.

A wonderful sunset caught on camera was the inspiration for the cloud formations on the planet. The **photograph** was scanned, cropped, rotated and then laid down in an area of the piece that suited best, allowing me to progressively paint out from there to complete the planet's atmosphere.

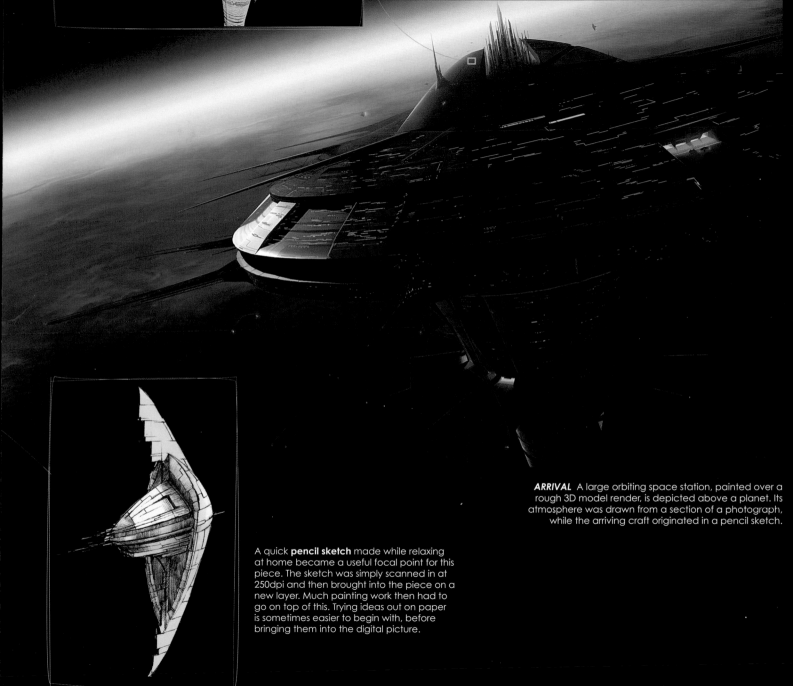

ARRIVAL A large orbiting space station, painted over a rough 3D model render, is depicted above a planet. Its atmosphere was drawn from a section of a photograph, while the arriving craft originated in a pencil sketch.

A quick **pencil sketch** made while relaxing at home became a useful focal point for this piece. The sketch was simply scanned in at 250dpi and then brought into the piece on a new layer. Much painting work then had to go on top of this. Trying ideas out on paper is sometimes easier to begin with, before bringing them into the digital picture.

TRADITIONAL MEDIA

All the skills and techniques you acquire in the diverse disciplines of creative art can be used in the digital realm: the understanding of colour, light and shade, brushstrokes and compositional balance are universal. Possibly of more interest to the traditional artist is the versatility that working digitally can offer. Many artists still prefer to work outside of the computer much of the time, using digital packages at certain distinct points in an image's development.

A few examples are:

• A traditional artist who is working up a commission in oil. They might line out what they want to paint on paper and then scan it into the machine so they can adjust some of the compositional errors and shapes, then have that image printed out to canvas at the final size to paint over.

• Working up a painting using pencils and then acrylics to what you could call a near-final state, then transferring the piece to the computer to add some special effects or to correct a few tonal anomalies. The final work can then be reprinted in any medium.

• Bringing a watercolour image into the computer to repair an area that inadvertently became too dark – anybody who works in watercolour will know how easily this can happen.

• Many artists draw out their ideas in pencil and then scan them in so they can work on the painting digitally. I have used this technique a number of times in the past.

Digital editing can be used to great effect to help artists complete difficult traditional paintings; the only real drawback is that if you do your final edits in the digital realm, you do not end up with an 'original' piece as you would if you started digitally and moved to traditional methods later.

STARTING TRADITIONALLY, ENDING DIGITALLY
Here is an example of the process of taking something traditional into Photoshop to finalize the piece. This work was created by a very talented artist and good friend of mine, Kevin Crossley.

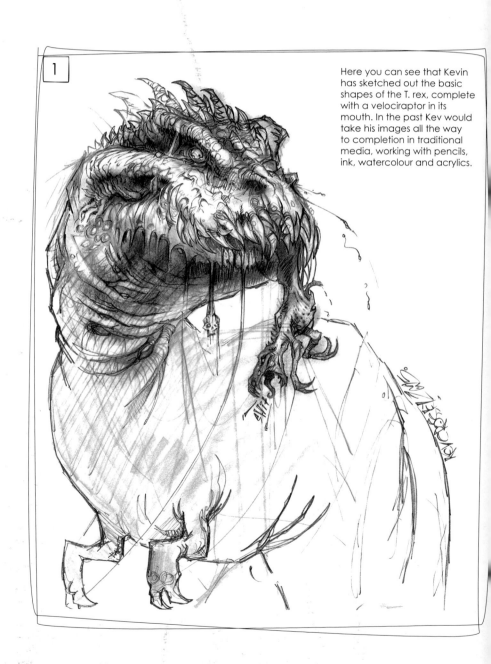

1

Here you can see that Kevin has sketched out the basic shapes of the T. rex, complete with a velociraptor in its mouth. In the past Kev would take his images all the way to completion in traditional media, working with pencils, ink, watercolour and acrylics.

By working digitally, Kev can indulge in some experimentation with the image. Here, he is toying with the idea of having a mountainous backdrop, which ultimately he did not like…

Bringing the image into Photoshop, Kev has now started working up a colour wash on the body of the T. rex. You can still clearly see the original pencil lines that he is using for a guide.

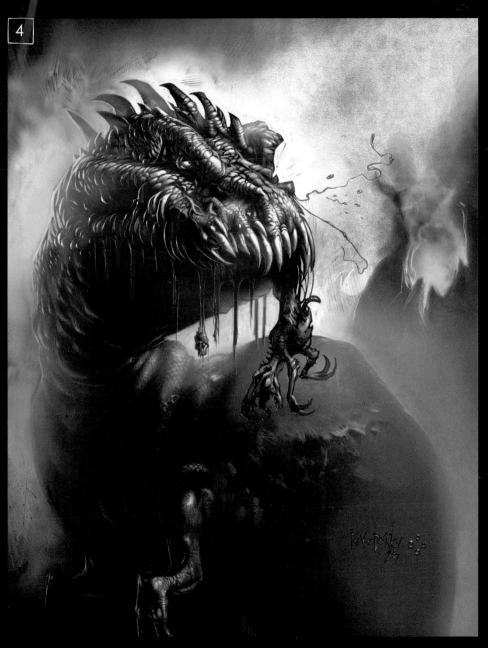

As you can see, he has changed the direction of the piece dramatically here and it is looking better for it. If he were working in acrylic he could have made this amendment, but it would have taken some time.

The final piece has a wonderful mix of organic brushstrokes and visceral shapes – brought to life by Kev's fantastic pencil skills and exciting colours, powerful contrast, detailing and atmosphere, created using the digital tools.

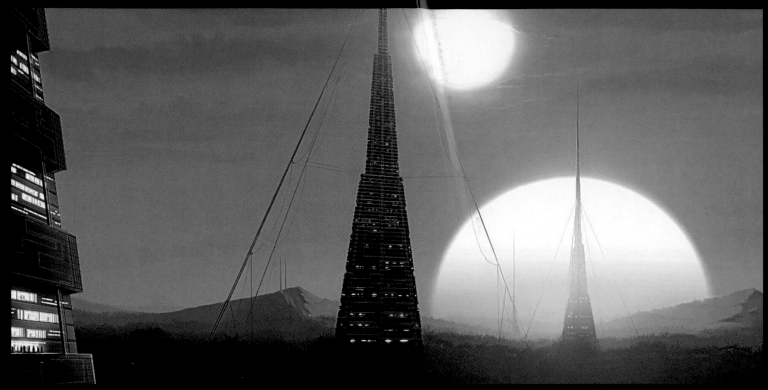

BINARY RISING A double sunrise on a distant world.

Basic Techniques

Just as traditional artists have clear preferences as to what type of materials they like to use, the position and size of their canvases and the manner in which they apply the paint to them, as a digital artist you can also set up and adapt your workspace to suit your personal tendencies. All artists have their own unique approach. No doubt you will have different preferences from me, not only in terms of your workspace, but also your tool usage. This notwithstanding, the basic techniques in Photoshop are very intuitive and the most common tools are covered here, with advice on how best to use them.

ORGANIZING YOUR WORKSPACE

The user interface inside Photoshop has gone through a number of iterations in the last few years, so what you see in front of you might not be exactly as you see it here. However, the majority of things have stayed the same; it should be fairly easy for you to find the items illustrated here whether you are using PS6, PS7, CS1, CS2 or CS3. On the opposite page you can see a screengrab from my machine giving you a good idea of how I have my workspace laid out and the different facets you can see in front of you on the monitor.

TOOLBOX: See pages 20–21.

The top area is dynamic and shows the relevant options for the current mode. Here you can see the brush options.

MENU AREA: This appears on the right by default. You can dock together whichever menu sections you feel are the most useful, or move them around the screen to your preferred locations. I like all my menus in one place, so this layout is typical for me.

NAVIGATOR: When zoomed in, this shows you exactly where you are in the image. It has a quick bar to zoom in and out, which I use a lot.

COLOUR PALETTE: I use my colour tools set to HSB (Hue, Saturation and Brightness) as I feel that is the most natural. I also have the gradient bar beneath set to Current Colors; this makes an automatic ramp between the Background and Foreground colours that you can pick from quickly.

Images that are open can be seen at the same time. Here, the top left image is active, hence it is on top.

This indicates open images that are minimized. Try not to have too many images open at once, as this chews your memory up

ADDITIONAL ICONS: Docked to the side of the menu are tools that I use from time to time, such as brush settings, text and paragraph settings and actions.

LAYERS PALETTE: This is one of the tools that really shows the potential of digital editing. If you are unsure about a new addition to a piece, or want to sketch some ideas safely, place it on a new layer. I try to keep layer usage down (as layers eat memory), but they are very useful (see page 24).

HISTORY: I find this useful when working on new ideas and effects. I can store a position and then use it to paint back to, or revert to (undo) if an effect needs softening, for example. This is a very powerful tool that I use frequently (see page 25).

PHOTOSHOP TOOLS

Photoshop is brimming with tools and effects that can help you paint, copy and paste, transform, smudge, sharpen and fix errors. There are so many, in fact, that an entire book has been written about them – it comes with your copy of the program! That said, on these pages I have given some information on the more frequently used tools in Photoshop. I have also labelled the rest of the buttons for reference.

SELECTION TOOL: Allows square, rectangular, circular, oval and other selections.

MOVE: Lets you move objects or layers around. Personally, I prefer to stay in Selection mode and hold down the Shift key to move the selected object.

LASSO TOOL: I tend to use the Polygon Lasso, but this tool also offers other modes such as Freeform and Magnetic Lasso.

MAGIC WAND: Useful for grabbing similar-coloured elements and powerful when coupled with other modes. Menu also contains a Quick Selection mode.

CROP: Quick and easy to trim (or extend) the canvas.

SLICE: For breaking images up for web use.

HEALING BRUSH: There are a number of related tools, used to fix errors in photographs quickly. This is useful for illustration too, although to a lesser extent.

PAINT: This is where I live! Other tools in this menu are Pencil and Color Replacement. I use Pencil from time to time, but I do not use Color Replacement.

CLONE TOOL AND PATTERN STAMP: Useful to quickly duplicate an effect or look from one area of the image to another.

HISTORY BRUSH: Very useful in my work. Also in this menu is the Art History Brush, which is similar but adds user-defined effects when used.

ERASER TOOL: This has various options – I tend to flick my tablet pen round and use that.

FILL AND GRADIENT TOOLS: I sometimes use this for passing colour effects over images (in Gradient mode).

SMUDGE (shown), SHARPEN AND BLUR: These are useful tools, if used with care.

DODGE (shown), BURN AND SPONGE TOOLS: Again, good if not used too aggressively.

PEN TOOLS: For creation of Bezier shapes and curves; powerful when used correctly.

TEXT TOOL: For adding and editing text elements.

PATH EDITING: Used to edit the shapes created by Pen tools, among other things.

LINE (shown) AND SHAPE TOOLS: I use the Line tool to generate my perspective lines.

NOTES: To overlay and annotate your images with any comments. Rarely used.

EYEDROPPER/COLOR PICKER: Picks up the colour from a selected pixel (or group of pixels) and sets it as the Foreground colour. I prefer to hold down the Alt key when in paint mode, which activates this mode dynamically

HAND TOOL: For shifting the view about. I use a shortcut to this by holding down the spacebar in Paint mode to drop into this mode dynamically.

ZOOM: For zooming in and out of images.

BACKGROUND AND FOREGROUND COLOURS: Pressing X when painting swaps you between them.

QUICK MASK ON/OFF: I do not tend to use this mode much, as I prefer to use layers for my work.

CHANGE SCREEN MODE: Swaps between multiple windows, single image on screen and full screen. I use the F key shortcut to activate this.

BRUSHES

The art of making a mark is the cornerstone of creativity. The tools you use to make your mark show through in the style of the end illustration, so it is important to be comfortable with the tools you use. When creating digital images it is possible to create a brush out of just about anything, leaving you with almost endless possibilities. You may find, however, that you discover a small group of brushes that do what you want and you will rarely need anything else. This is much how I work, so here I have drawn out some simple strokes using one of my favourite brushes, adjusting some of the many options to show the different effects created by these. The options I have shown here are merely scratching the surface of what is possible within the Brushes palette. I suggest that you have a thorough play with the Brush tools as you will undoubtedly find a completely different set of brushes that suit you and make your painting process more enjoyable.

I have laid down three brushstrokes here, each one with less total pressure on the tablet than the previous one. As you can see, at the start of each stroke I start with a light touch and increase the pressure as the stroke continues. As the pressure increases, the Opacity on the brush and the size both become greater. This is because I have Pen Pressure set to Size Jitter and Opacity Jitter in their respective submenus.

In this case I have painted the strokes much the same as I did in the red paint pass. However, I have unchecked the Opacity Jitter option; the strokes now have a different scale depending on pressure, but the line stays the same colour throughout the stroke.

Now I have rechecked the Opacity Jitter option, but unchecked the Size Jitter option. The effect is a uniform size of brush, but with a dynamic transparency across the stroke.

This time I have unchecked both the Opacity Jitter and Size Jitter options. As you can see, both these strokes are now essentially the same.

On this stroke I have checked the Scatter Jitter and set the Scatter Amount to a large amount. The result is a speckled look as the brush becomes offset from the direct line of the stroke depending on the pen pressure applied.

Leaving the Scatter Jitter in place I have now added another option – Foreground/Background Jitter on Pen Pressure. The Opacity settings are unchecked to illustrate the result better, but as you can see, the brush colour changes from the Background colour to the Foreground colour depending on the pressure on the tablet.

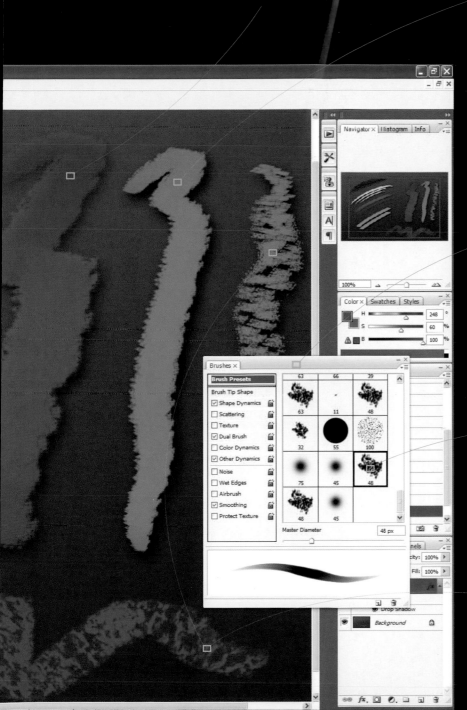

This is the New Brush section and Adjustment toolbox in CS3. I normally have this docked at the side of the main menus at the upper right part of the screen. This allows you to choose brushes, create new ones, apply adjustments on how current ones are behaving and save the results.

The brush I have selected is a blocky bristle type with its standard size set to 48-pixel diameter. You can see that there are a number of options checked for the current brush: Shape Dynamics, Dual Brush, Other Dynamics and Smoothing. There is also a preview at the base of the toolbox of how the brush will behave. This brush has made the red marks you can see at the top of the screen.

In these final two strokes I have used a selection of modified Scatter and Dual Brush settings to produce these effects. The bottom stroke uses a distinctively different second brush in the Dual Brush settings, giving a randomized, almost pastel, look to the stroke. The right-hand stroke uses a similar second brush shape and a little more scatter to produce the effect you can see.

LAYERS AND HISTORY

Few things define the enormous jump forward that working digitally offers than the ability to work on separate layers and to be able to hold a history to undo actions. These two elements allow you to be braver and more imaginative with your work, knowing you can try out something new and 'dangerous' without the fear of losing what you had before, also keeping that safely away from the rest of the piece if you want to. There is a lot of power in both the Layers and History modes that can be delved into, but I have shown here how I use these tools practically to keep the painting process smooth.

PRACTICAL USE OF LAYERS

Here is an example piece to show how you might store your layers while working on a piece. This work-in-progress image, *Azurian Core*, is a snapshot of where the piece was about 60 per cent of the way through it (see page 11 for the final image). At this point, the image was broken into five distinct layers so I could add and edit areas of each knowing that the other layers remained intact. These layers covered disparate elements in the piece, as you can see here.

I use perspective lines all the time in my work and this piece was no exception. I get the lines how I want them and then lock the layer. You can then turn the layer's visibility on and off when you need it and delete it when the piece is completed.

For something experimental – this glow being a good example – make a new layer (note that this layer is also set to Lighten). You want to keep it clear of the other image elements, just in case it does not work.

Clouds that affect the underlying scene are something that can become quite complex to balance. By putting them on a separate layer you can safely edit and alter these clouds to see how they complement your image.

The planet layer is a good example of something you might want to keep separate. Once you have roughly drawn out something like this, you might find that you can improve the composition somewhat by carefully placing these elements as the rest of the image progresses.

The background layer is holding much of the detail of the image. Unless you think the elements you are adding are contentious or might need heavy editing or work, try to keep as much as possible on your background. This will save memory and keep the drawing process more fluid.

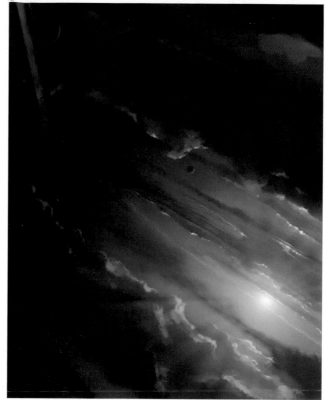

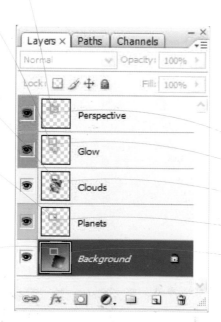

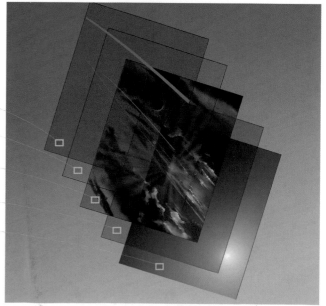

USING HISTORY EFFECTIVELY

By default, Photoshop stores the last 20 actions you added to each image opened. This number can be altered in the Preferences menu, although I tend to keep it to this level as a large History log eats a lot of memory. However, it is possible to store specific states as you paint, to refer back to or paint into at any point. Here is an example of how this might work using the same image, *Azurian Core*.

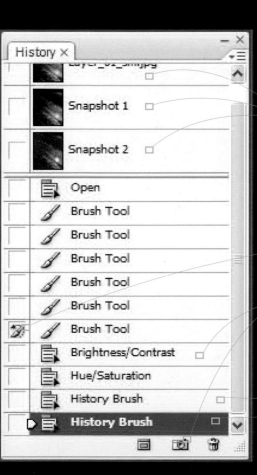

At the top of the History menu you can see the original loaded state at the top and then two subsequent Snapshots taken during the process of performing the actions you can see below. The first Snapshot was taken after I added the brushstrokes; the second was taken after performing the Hue/Saturation pass.

If you are thinking of performing a radical alteration to the image, such as the Brightness/Contrast or Hue/Saturation passes here, it might be a good idea to take a Snapshot before you do this, just in case you do not like the result when you look back.

At any time you can add an additional dynamic state that you want the History Brush to refer to when painting. This is currently attached to the last brushstroke, but could be applied to any point, Snapshot or the original loaded file.

Selecting the History Brush state at the point just before the two colour-effect passes allows you to paint back to the state selected. Here you can see I have added strokes with a large soft brush across the top of the image, painting back towards the original blue colour.

LINE ART

To demonstrate the simplicity with which you can draw in Photoshop, I have laid out an image that has been created almost exclusively using line art, with a little tonal shading in certain places. The tools I have used are just the Paint tool, a single type of brush, the Foreground colour set to black and the Background colour set to white. I then simply used the X key to swap between the colours and the number keys to give me control over Opacity (1 = 10%, 0 = 100%, so quickly pressing 54 would give me 54%). No other tools were used except in the final step.

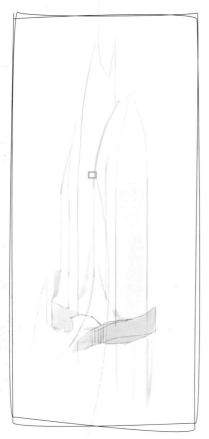

Try to create smooth and confident lines – if a line goes wrong when you stroke it, undo (Ctrl Z) and try again until you are happy.

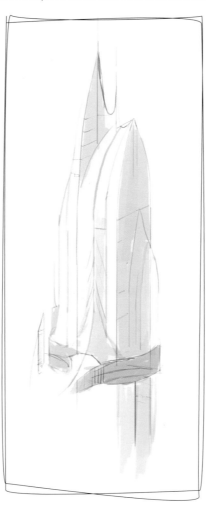

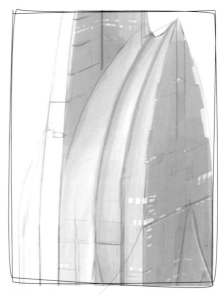

Adding windows immediately shows the viewer what the scale of the building is.

Step 1: Sketching in the first lines

It is important to have a solid idea about what you want to paint or some good references to hand when establishing the fundamental shapes of a subject. Draw out the lines that facilitate the outline of the subject first; in the case of this building, I wanted to have a number of organic-looking layers to the structure, but a strong engineered look to how they are integrated. If you want, place some simple shading on some faces to help punch out the shapes.

Step 2: Adding more detailed lines

When you have the shape worked out, you can progress to adding some details that explain the direction of different surfaces. I've added a little more shading here as I find it helps me work with the subject more efficiently, although many artists wait until they have the image completely lined out before starting to shade. Work however you feel most comfortable.

Step 3: Tightening lines and adding shapes

Even though this image is just a layering of lines and larger brushstrokes on top of each other, this is no reason to not add little flecks of detail to describe the scale of the subject. While you are adding detail, increase the cleanness and sharpness of the major lines, as you will need these to underline the features in the final piece.

Step 4: Working up details

Working more and more layers of lines on to the piece will bring the subject to a coherent state. As before, you may prefer to wait until you have all your line detailing in place before you start shading, or you might find it easier to add your shading on to another layer, so you can change it without affecting the lines that you have spent time honing.

Step 5: Performing the final pass

Whether it's an image that has taken 30 hours of painting or a sketch that has taken 30 minutes, your work deserves a final pass to help mesh all the elements together. Here, I have added a cloud cover layer to further emphasize the height of the building. Note that I left out any smooth shading or details on the bottom part of the building in step 4. This gives the piece depth and helps transform a simple line-and-tone image into something that could be called an illustration.

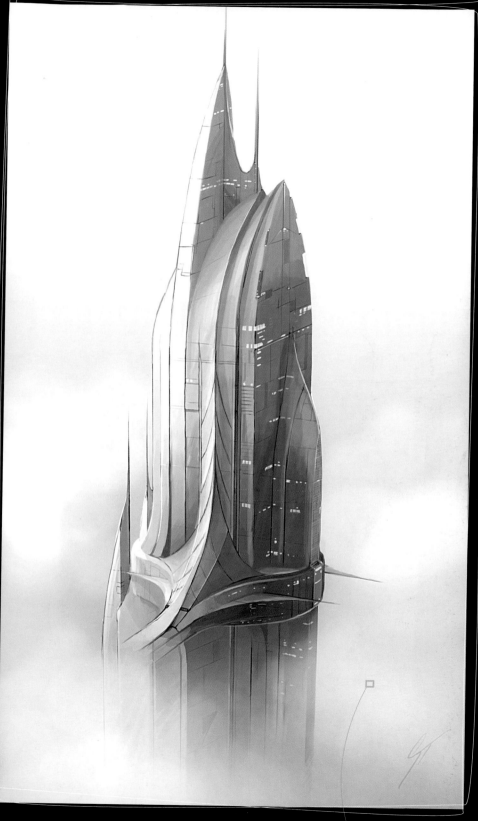

Clouds were added with a soft circular brush set to a low Opacity.

PAINTING WITH COLOUR

This is my preferred method of creating images – I love being able to express shapes, depth and emotion using colour and light. You might find that you prefer this type of painting style too, but many artists are much more comfortable lining out things in great detail before taking the leap into colouring a piece. As far as digital workflow goes, either way is just as simple. Like the line art tutorial (see pages 26–27), I have only really used one type of brush and this image was created on one layer, without the use of perspective guides, so the end result is nice and loose. Unlike the line image, this piece will be created with just brushstrokes and any detail added will be formed out of the loose shapes as the image progresses.

Step 1: Laying down a colour wash

When you are working in this way, laying out a rough colour wash is a very good starting point. Do not worry about making it neat – with this type of piece you want to feel free to work loosely, so start as you mean to continue. This image is going to be set underwater, so the blue-to-lighter-turquoise wash works well.

Step 2: Adding a focal point

With the colour wash in place, start playing with some ideas. If you are worried about working directly on to the background, create a new layer to work on until you are surer of the shapes. I have tinkered a little here before settling on this shape (note the lighter scribbled area below the submarine craft). You will also notice that I am already painting a rough light direction in – the light is coming from above and slightly behind the craft. Just stay focused on using colour and light to guide the image creation.

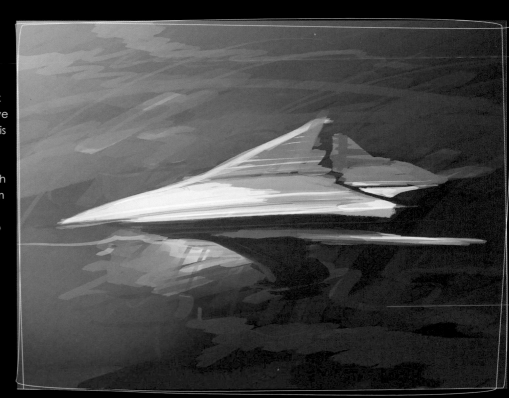

Step 3: Enhancing the background

To help balance the composition and lead the eye further back past the craft, I have added a larger structure that the submarine is moored to. Even though you are working loosely, try to ensure that when you add depth-defining elements you keep the major perspective edges neat and easy to read (note the platform coming towards the viewer) – add them with more strokes of colour, light and shadow.

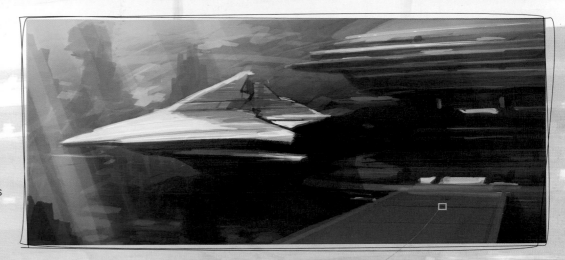

Depth and perspective are created by this platform moving off into the distance. It is important to get elements such as this right, as they are key to the image's compositional depth.

Step 4: Adding atmosphere

While adding details and elements to the piece I have also been layering atmospheric effects and diffusion with low-opacity brushstrokes. Try slowly building up the distant objects in the scene, such as the large rocks jutting up here. Keep using loose brushstrokes to build up your colours and shading, and continuously find ways to illustrate the lighting and materials with colour and tone.

Add a touch of complementary colour to the scene, such as this red flash down the craft.

Use light from windows like this to illustrate life and to draw the viewer's eye. These were added using a Color Dodge brush.

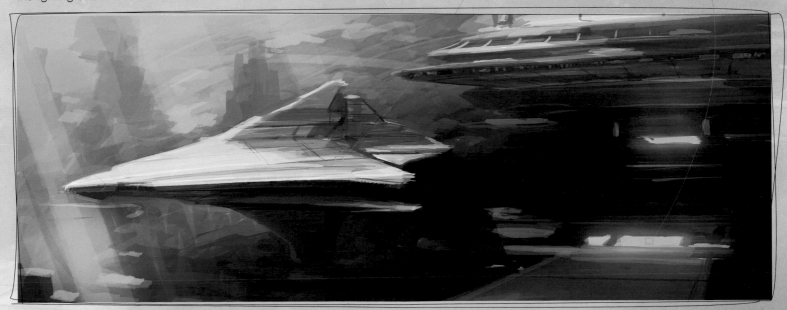

Step 5: Sharpening the important areas

Now you have a lot of the elements in place, work on sharpening the lines and silhouettes of the focal areas of the piece. Here, I have been working on punching out the lines that define the craft's edges. You can see how the colours and tones are defining the shape strongly – the underbelly of the craft is in deep shadow while the upper side is bright and colourful.

It is very important to understand where your lighting is coming from when painting with colour. Keep this in mind all the time you work on the image.

Step 6: Adding the final touches

Working up the final details on this piece involves making sure that all the elements mesh together and that you have added adequate detail to describe all the important features. I performed a simple Brightness/Contrast pass on this piece as it neared completion, just to help punch out the shapes and add depth and drama. The final piece is loose, but it does the job well – an entire image painted without a black line in sight.

Framing the image with silhouetted coral helps add even more depth to the piece.

Scale reference is created by windows and the people on the platform.

Cascading light into this piece helps add depth, but also intensifies the atmospheric feeling of an underwater world.

Note the little areas of the dock that pick up light from the open doors; this helps explain the shape of the object and also the material it is made of.

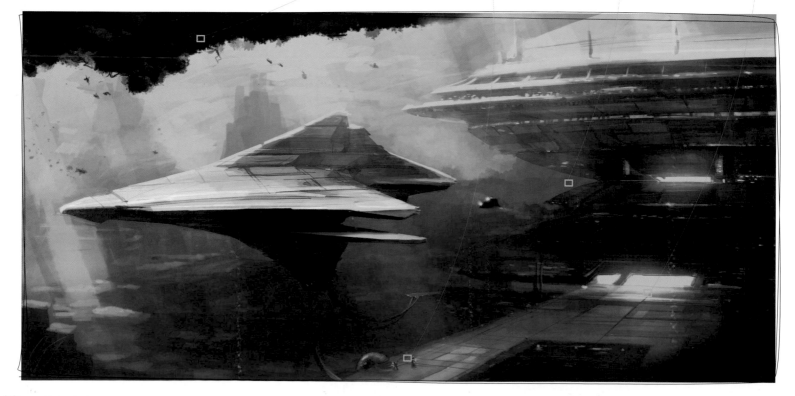

MOUSE OR TABLET?

You might be wondering what all the fuss is about with graphics tablets for digital painting. If you have not used one, it might not seem like a more effective way to create images digitally. After all, the mouse is a very good and accurate tool for 3D and 2D packages alike, being consistent and easy to use when you change from one program to another. Indeed, I worked with a mouse to create my artwork from 1987 until 2001, thinking it was the most efficient tool for the job.

When I finally tried out a tablet, it took me about 20 frustrated minutes to adjust to using it, but after that time I enjoyed myself enormously. After two hours of painting with it I felt as if I had wasted a lot of time not using one. Although a mouse can give you the accuracy for pointing at elements on a screen, it cannot offer the feedback that a tablet gives you when painting. If I draw with a mouse today it feels as if I am parking a car – it is slow, clunky, and I worry about hitting parts of the image that I don't want to. Add to this the fact that tablets detect the pressure and angle from the pen and the fact that you can now buy screens to paint directly onto (which I highly recommend), and you might have an insight into the enormous jump offered by painting with a tablet as compared to using a mouse.

Those moving into the digital arena from traditional media today will no doubt work with a tablet straight away and never even consider using a mouse. However, if you have been happy with your mouse up to now and are yet to be convinced by tablets, just try one out – I doubt you will find a more emancipating moment in your art than the first time you use one.

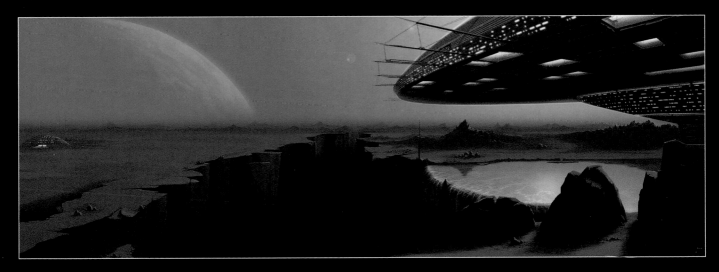

COLONY This image was painted in 2000 with my trusty mouse. It took about 40 hours of painting time. Note how tight the details are. If I were to paint this again today using my tablet it would take less than half that time and the end image would be braver, looser and undoubtedly better for it.

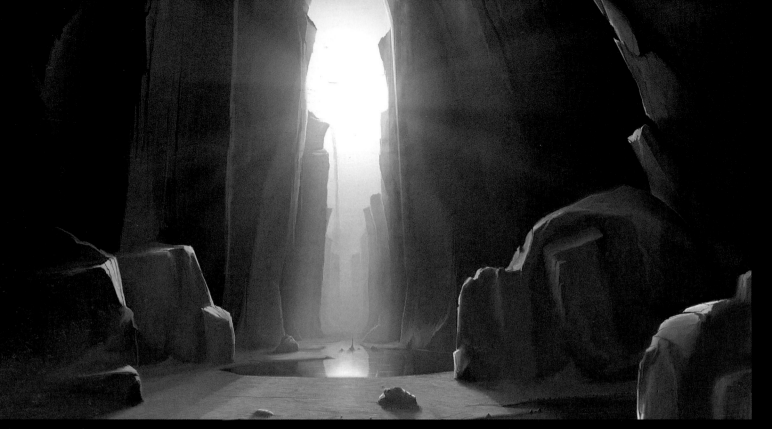

NASCENT (crop) Dawn on a
very young world.

Colour and Light

**It is impossible to overstate just how important colour and light are to producing
strong, believable imagery. Much of what draws the eye towards a focal point,
balances a piece, or adds solidity to a subject is the viewer's belief in the scene.
Subconsciously, this is controlled by how well the lighting and colour are represented.
It is not imperative that lighting and colour work looks 'realistic' in the strictest sense
of the word, but it must be believable. It is perfectly legitimate to conjure a wild and
fantastic scene filled with exciting colour and light, as long as there is enough within it
for the viewer to understand how it works and buy in to the concept. However, for the
newcomer to the world of light and colour, it is paramount to start by understanding
how tones influence the feel of imagery and how light and shadow sew the subjects
together into a final scene. This chapter looks at light and colour individually to
understand how they work together and separately.**

COLOUR CONCEPTS

Colour is very powerful. Firstly, let's explore a few different concepts and examine how different colour themes and
usage can radically alter the final feel of an image, from monochrome palettes through dual tone imagery to the
careful use of colour to project temperature, depth and emotion.

1 I used a very quick wash of tones to establish the rough composition. Looked upon simply, the piece has a dark bottom and a light top.

2 I added a little detail to the rocks and used the brighter tones on the stairs to lead the eye. Think about where in the image the light strikes.

3 I then reinforced the image's focal point by brightening up the distant higher ground.

4 The final composition has scale and drama achieved by the inclusion of human figures and some subtle atmospheric lighting. Use tone to carefully pick out lighter and darker areas.

MONOCHROMATIC PALETTES

To start with, try painting up an image using one light source and tone only. For a monochrome, or narrow-chrome, image you only need to think about how light is travelling through the represented space you are depicting. As you can see here, I have gradually built up this piece using simple brushstrokes, focusing only on the tonal values and not worrying about how the different materials might be represented in colour.

Working like this can help you to understand how light rays might stream out from a source through a piece, bouncing from one surface to another, and also how much can be accomplished simply by picking out little details with highlights or shadows. In the final image I have added a flourish of slightly different colour as it approaches the focal light source, but the image works just as well in monochrome.

DUAL-TONE IMAGES

Dual- or multiple-tone images involve more in-depth
contemplation about how you might want to represent
the subject matter. Many dual-tone images will break
down into two distinct light sources. The colours of
these separate lights will normally complement each
other (but do not have to), such as in the image here.
The use of a cool blueish focal light towards the right
of the piece offsets the more diffuse but vibrant red
second light source. By selecting the position and
strength of the two (or more) light sources well, you
can ensure your scene objects will be lit in a pleasing
and interesting way.

The diffuse red light has been positioned
to cast a warming glow on to the pillars
lining the walkway, but it has also been
placed low enough so that the light does
not strike all of the pillar, allowing some of
it to fall into shadow.

The primary light has a multiple purpose: it draws
the eye into the depth of the piece, creates the
opportunity for long shadows to be cast across the
walkway and also allows for interesting silhouettes
from the pillars as they fall away into the distance.

The position of both lights allows you to rim
light certain details – picking out the very
edge of shapes, such as the underside of
the narrow bridge, for example.

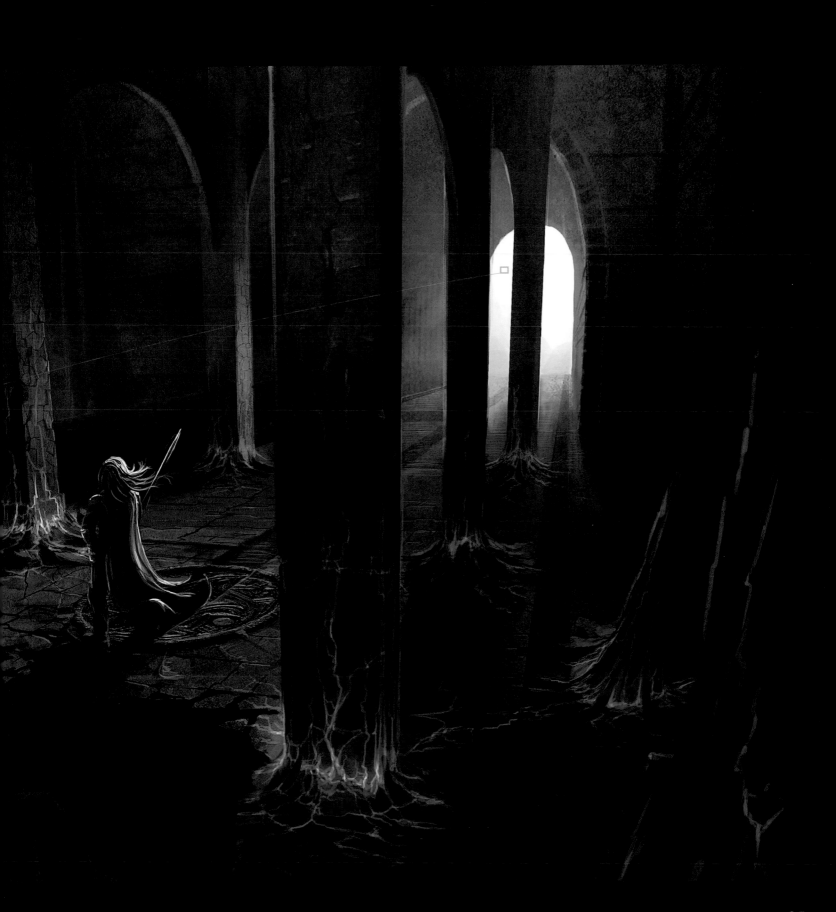

COLOUR TEMPERATURE

When using strong colours in illustration, there is always going to be a balance between warm and cool hues; the choices you make with these will greatly influence the feel of the finished image.

Notice that I have used the light source as a focal point. By doing this you have the opportunity to punch out exciting silhouettes in the scene, describing the distance and perspective wonderfully.

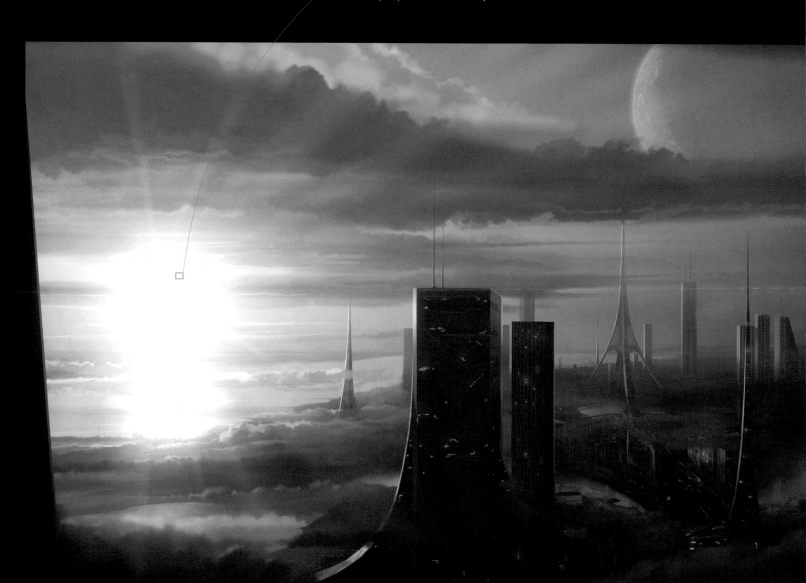

WARM

Hues towards the red end of the spectrum tend to conjure a feeling of warmth and brightness, mainly due to how we experience these hues in nature (a warm sunset or a raging fire, for example), so predominantly using these hues in an image will help describe these sorts of situations. Conversely, it would be quite a challenge (although not impossible) to represent a sunrise with cooler blues, for instance. If you are using a lot of warm colours in an image, it can be very useful to counterpoint these hues with a smaller number of cooler complementary tones, as can be seen in the image *Radiance* here. By doing this, you show the viewer that although there are a substantial number of warmer tones in the piece, they are not being caused by a full-screen filter or effect, but the actual light being radiated by the primary light source, because the cooler tones are preserved in shadow.

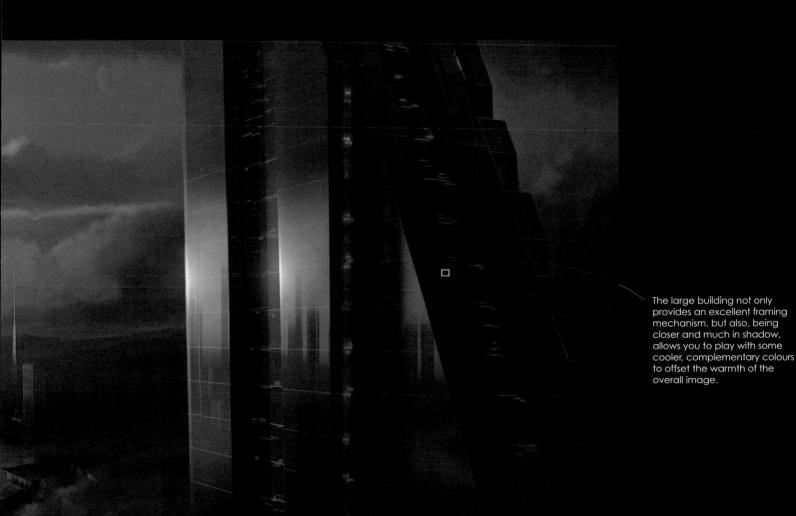

The large building not only provides an excellent framing mechanism, but also, being closer and much in shadow, allows you to play with some cooler, complementary colours to offset the warmth of the overall image.

The use of dark craft is intentional; they give the impression that this place is undeniably cold, conjuring mystery and a feeling of awe.

COOL

Cooler tones are more often than not associated with serene, tranquil or colder conditions. It would be fair to say that you would find it very hard to represent a lava flow with shades in this range, for example. However, an ice cave with glistening snowflakes drifting downwards would work brilliantly using these hues. Again, look at how these colours are seen in nature and you can start to analyse how best to use them and how far you can bend the rules when creating interesting fantasy and sci-fi art with them.

Cool shades work excellently to complement warmer tones, for instance using these hues to illustrate shadowed areas when using warm tones to represent areas struck by direct light. With this image I have deliberately used cooler tones to represent a hot light source. Although the viewer can read the star for what it is, the image still gives off a feeling of tranquillity and relative coldness.

It is important to remember how powerfully your choice of tone will affect the overall feeling of an image. I would recommend that you experiment a great deal with different palette concepts and swatches with both predominantly cool and warm colours to see what works best in your particular illustration.

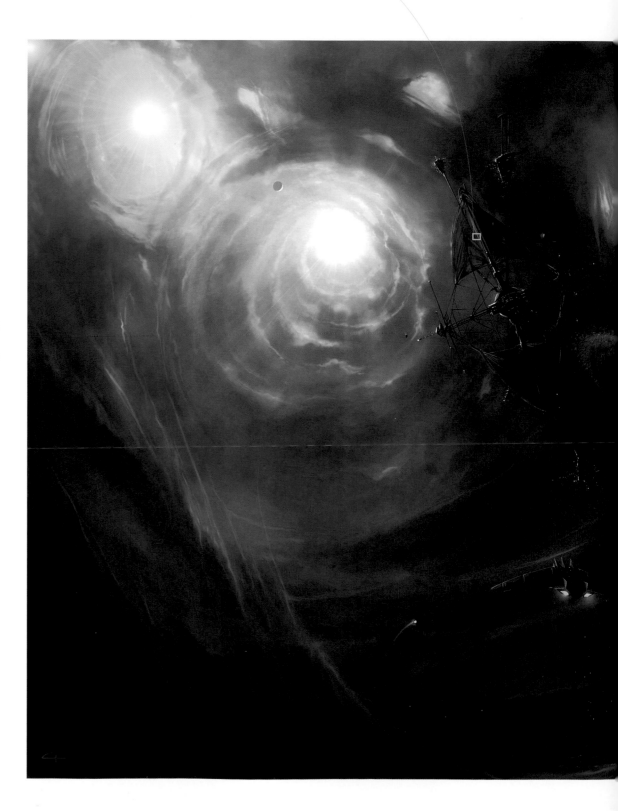

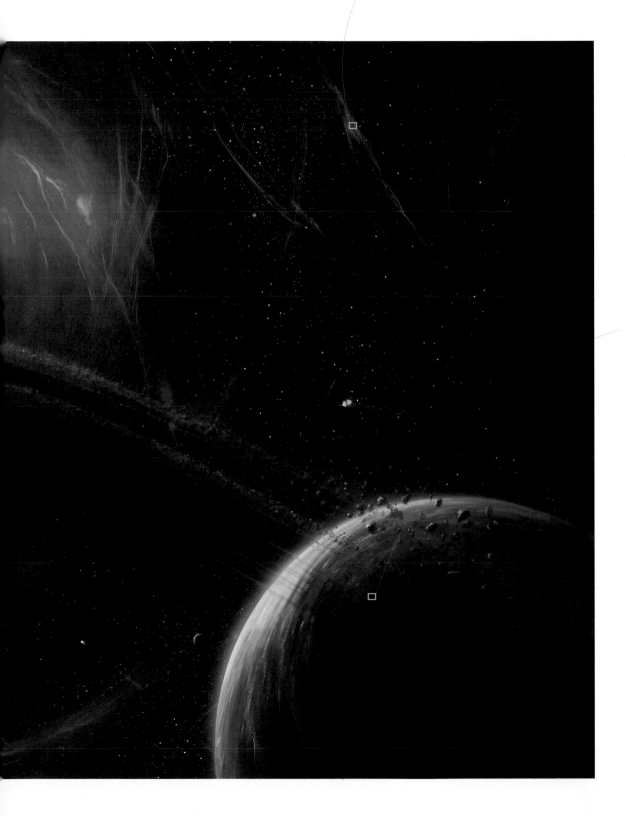

Adding to the tranquillity of the scene are the gentle drifting clouds; backed up by the cooler colours, these give the piece a majestic and calm feeling.

The ringed world, although bathed in light from the star system, feels cool – cold, even.

WORKING WITH COLOUR IN PHOTOSHOP

One of the most dramatically different aspects of working digitally is the ability to alter or totally change the colouration, saturation, contrast and brightness of the image you are working on, at any time. Within Photoshop there are many tools you can use to choose and control colours.

CHOOSING COLOURS

The simple Color Picker shown right allows the user to drop into it and very easily move the two target points about, altering the output colour. The target point on the right selects which part of the spectrum the colour component will come from. The left-hand target area, which is larger, allows the user to then select how bright and saturated the colour component is. Try playing around with these sliders a little and you will soon see how they make sense.

When working with an already established image, I tend to use the dynamic Color Picker: simply hold down the Alt key when in Brush mode and then click on a pixel of your desired colour on the screen. This colour will then be selected as your brushing colour. This allows you to change shade quickly without having to open up new menus. I also use the more compact Color Menu, which is located along with the other menu types to the right of the screen by default. This option allows me to work quickly and fluidly instead of dropping into a separate menu to choose colours.

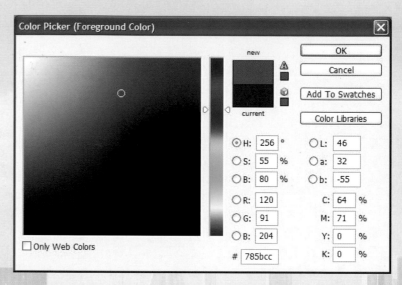

MANIPULATING COLOURS

There are so many options, controls and variants to control image colouring in Photoshop that to give them all full detail would take up the rest of the book. What follows is a brief breakdown of some of the major filters I use, and what they each offer. The best thing to do is to explore these options and the effects they have on your own images to become better acquainted with them.

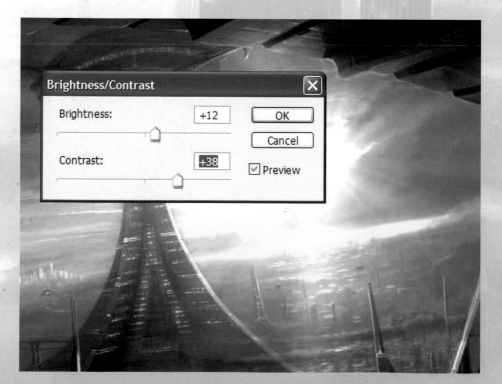

BRIGHTNESS/CONTRAST

This is a useful tool for adding a little extra punch to an image (by upping the brightness and increasing the contrast between highlights and shadows) if you find that it is lacking in tonal range. This mode has been updated in CS3, allowing smoother alterations to be carried out (although the older control is still there if you choose).

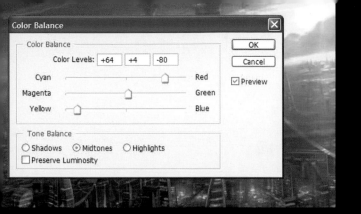

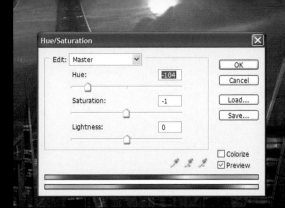

COLOR BALANCE

I use this quite a lot for subtly changing the hue balance of an image. You can shift the colours towards any of the primary or secondary colour values within the shadows, midtones or highlights of the piece. Much can be learned by experimenting with this tool.

HUE/SATURATION

This allows you to adjust the image globally, or locally, shifting the hue (for instance shifting everything that is red towards orange), reducing or increasing the saturation, and shifting the brightness of the image. Again, there are many possibilities so playing around with this tool is worthwhile.

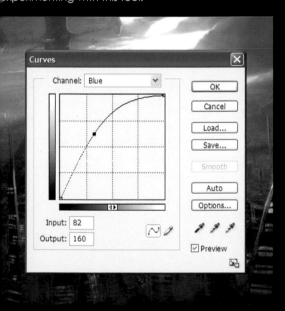

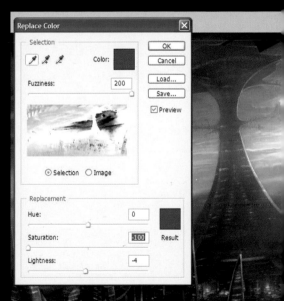

CURVES

You can control the curve of the whole gamma of the image from here, or single RGB components, creating complex curves to contour the influence of colours from zero to full brightness. Once again, experimentation is the key.

REPLACE COLOR

With this tool you can choose a colour (or colours) and then a degree of influence from that colour to control. Then you can shift the values much like you do in Hue/Saturation, but isolating it to the colours you have chosen. Very powerful with experimentation.

OTHER OPTIONS

There are numerous other filters and modes for colour tweaking, so I recommend that you spend some time poring over the Photoshop manuals and, more importantly, playing with the tools to find how they work for you. Much like painting digitally, these tools are used in diverse ways by individual artists; many of my friends use modes and filters totally differently from the wo

THE POWER OF LIGHT

Here are two images that underline the importance and influence that lighting has on a scene. These images are quite different but they both rely greatly on the way the light falls into the scenes and how the materials diffuse, bounce and alter that light to create believable atmospheres.

Look how the main light source is pouring into the scene, between the large roots of the towering tree.

Notice how I have burned the colours in places, giving the impression that you need to squint. This gives the viewer the impression that the area is dark and the light source is strong.

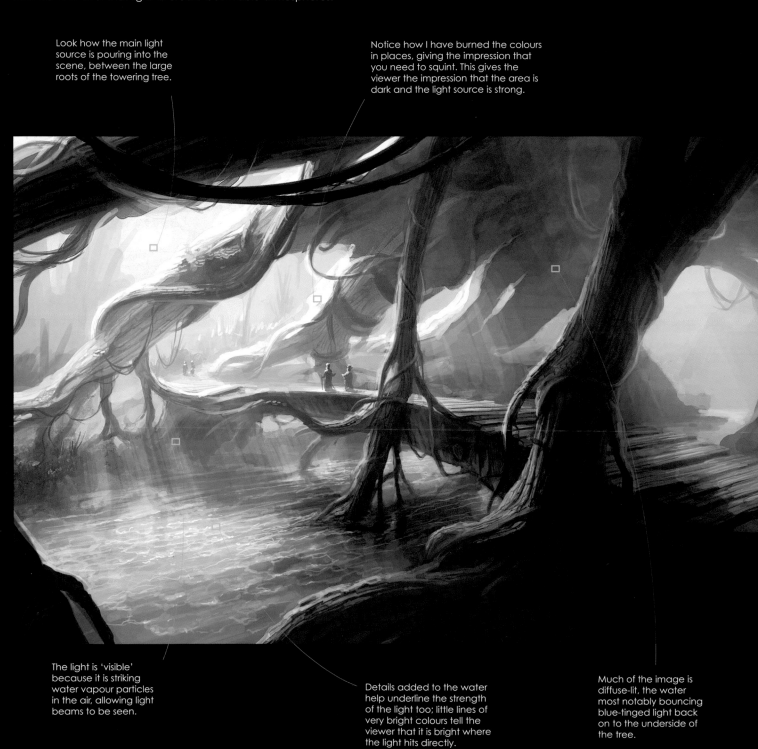

The light is 'visible' because it is striking water vapour particles in the air, allowing light beams to be seen.

Details added to the water help underline the strength of the light too; little lines of very bright colours tell the viewer that it is bright where the light hits directly.

Much of the image is diffuse-lit, the water most notably bouncing blue-tinged light back on to the underside of the tree.

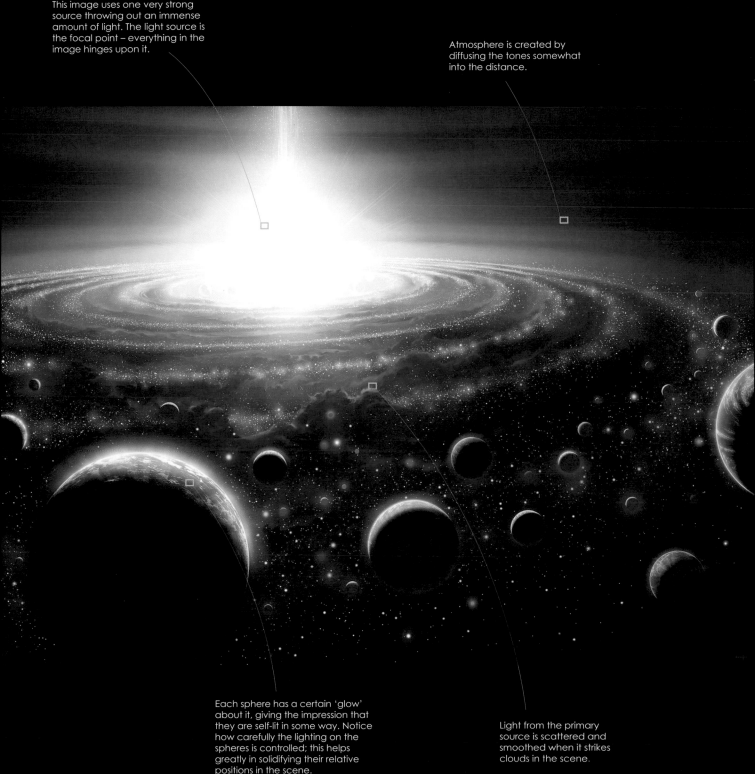

This image uses one very strong source throwing out an immense amount of light. The light source is the focal point – everything in the image hinges upon it.

Atmosphere is created by diffusing the tones somewhat into the distance.

Each sphere has a certain 'glow' about it, giving the impression that they are self-lit in some way. Notice how carefully the lighting on the spheres is controlled; this helps greatly in solidifying their relative positions in the scene.

Light from the primary source is scattered and smoothed when it strikes clouds in the scene.

AFFECTING A SCENE WITH LIGHTING

It can be very useful as an artist to analyse what makes a scene conjure the emotions that it does. One way to do this is to paint in, or remove, features from the final scene. In this case I want to demonstrate how an image can be completely altered by simply changing the way the light works. Importantly, I have not moved any lighting, just changed the hues and tones.

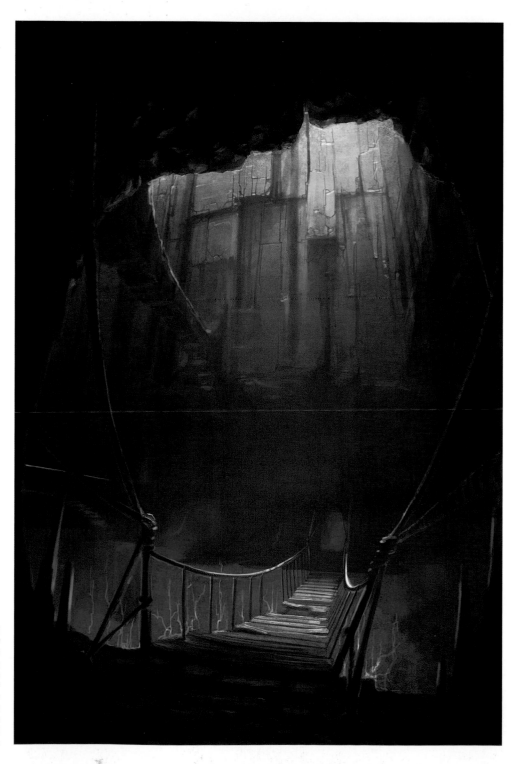

A SENSE OF HEAT The original painting is a good example of how a complementary palette, used in balance, can achieve an exciting lighting situation. Even though there is quite a significant use of cool blue/grey tones in the scene, the slightly more generous red and orange tones, used aggressively, make the image feel very warm. You can feel the heat coming from below.

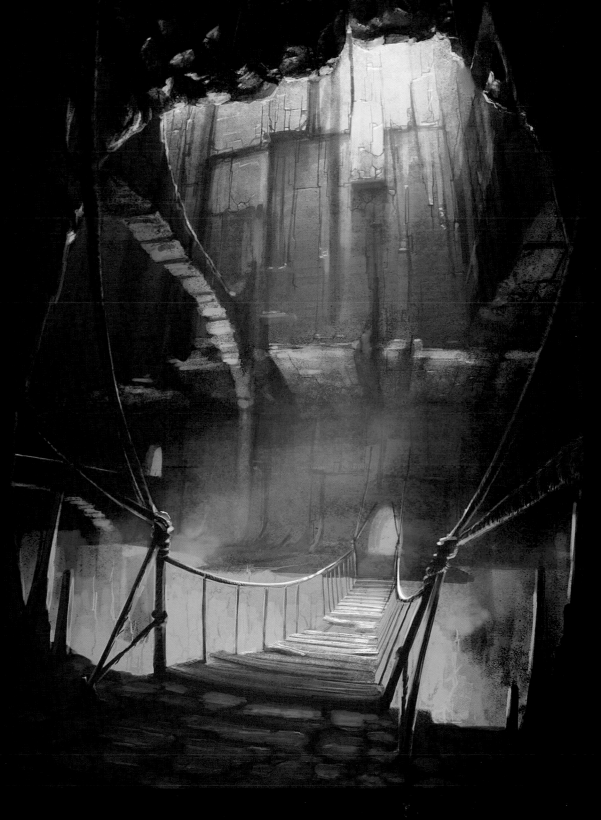

COOLED RIGHT DOWN
On this edit I have made a few detail modifications, but most importantly I have totally repainted the colours of the primary underlight. The end result is an image that creates a very odd sensation. The light from above is cold and sharp, but the light emanating from below has an icy feel to it. Some people might read these colours as being ethereal or spiritual, but there is no way you could read the image as being warm, even though the intensity of the light is at least as bright as the original.

SHADOW AND DEPTH-INCREASING TECHNIQUES

This step-by-step demonstration of a speed painting illustrates how adding lighting, shadow work and depth to a piece can completely transform it. You can see as each step moves on how the image becomes more coherent, deep and interesting.

Step 1: Shapes

The basic shapes are all in place at this point – note how you can see the position of all the architecture. At this stage, the scene does not read well as there is not an effective lighting set-up to settle the subjects into the scene. Likewise, there are no shadows to sew the objects together.

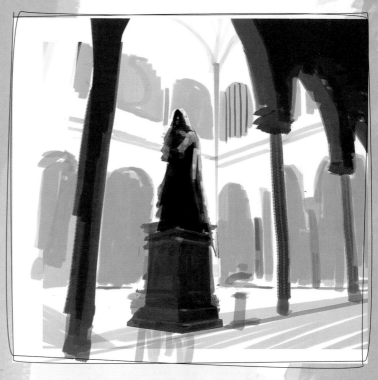

Step 2: Colour and shadows

I have washed a little colour over the piece here, but more significantly, I have imagined the line of shadow that will pierce the scene, drawing a line of muted, diffuse colours across half the room. This has suddenly added a great deal of depth, perspective and scale to the composition. Placing shadows on the far wall has also added another layer of depth to the scene – you can now understand that the wall is set back from the columns.

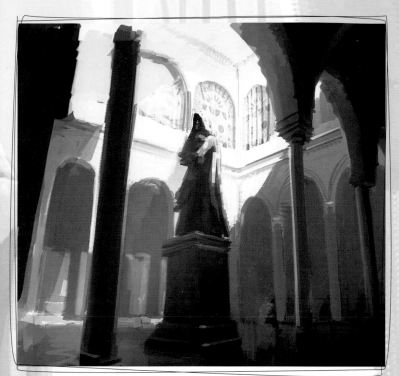

Step 3: Lighting

I have intensified the drama further by adding streaks of light crossing the room in the direction of the shadow line. As you can see, these brushstrokes have brought the brightness of the distant walls up greatly, emphasizing the scale of the room and the intensity of the light pouring in. The statue is being brightened too, but I have been careful not to over-brighten it; it is closer so there is less light between it and the viewer.

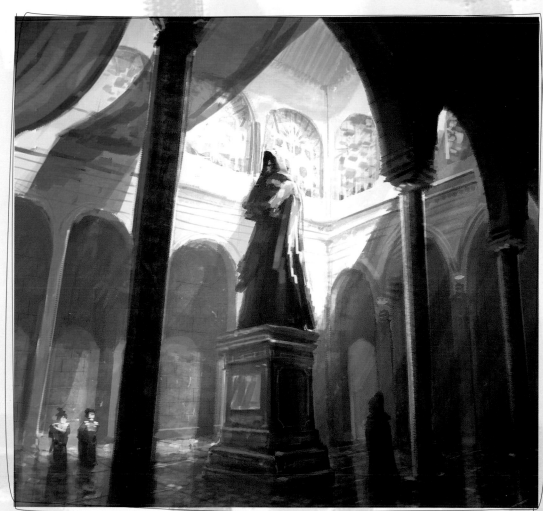

Step 4: Detailing

Adding details and highlights increases the depth of the piece greatly. Draping red cloth across the ceilings allows flourishes of red-tinged shadows to cascade down the far walls, and warm colours to be reflected off shiny surfaces, such as the columns. Reflections used elsewhere in the image also help to add depth – such as the door in the distance, and the gentle shapes of the people reflected in the polished floor.

Concept and Design

'Concept work' is the term used for the time when artists conceive and try out new visual ideas, shapes, colour schemes, backgrounds or characters. What you can gain from a solid conceptual phase is a greater understanding about what you want to achieve with the final image or images. Building up plans, pencil sketches, colour keys, line drawings and even just ideas in your head will help you to find the right direction. Get yourself into the practice of working through ideas in this way; you will find that on many occasions it will help you through any sticking points to a final image more quickly and with stronger results. In addition to the personal benefits, if you do ever cross into the professional arena you will find that many clients want to approve the rough conceptualization of ideas before moving forwards with a commission.

WORKING FROM A BRIEF

A lot of the concept work I do involves working from a brief supplied by a client. In addition, I often have different elements from which to originate the 'look' of a piece, such as photographs and specific colour palettes. The following sequence demonstrates how I work from these references to create a finished painting.

BRIEF

A mech-planet construction site. Enormous planet-shaped craft being assembled in the swimming gases of a blue nebula. These constructions are massive – possibly 15–20km (10–12 miles) in diameter, so you can see a curve to the shape but it also has its own horizon. Gas is thick around the structures, much like atmospheric water. Palette should be mostly restricted to cool blues, with one additional colour to pick out details.

This image is an interesting view of an underwater rock formation. The light from above creates great atmosphere. This is a montage made from a number of photographs in my collection.

The brightly lit water shows an interesting cloud-like light diffusion that I want to emulate in my painting.

The darker areas in silhouette give a good impression of the feeling required from the structure of the mech construction site.

The colour palette for this scene is restricted, and falls into the monochromatic scale, with a touch of complementary colour in the form of red.

15-minute rough colour and composition test.

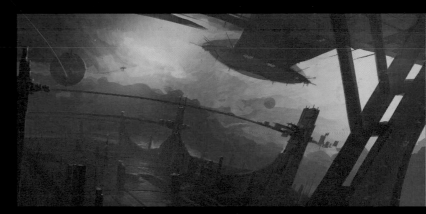

50 minutes' more work – large shapes in place.

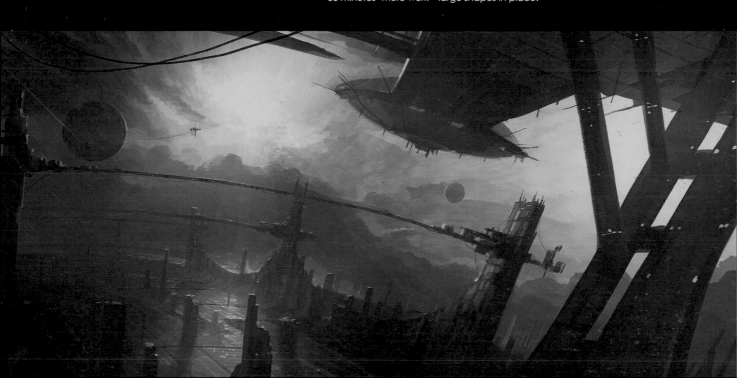

EXPLORING A THEME

Let's imagine that you are about to start work on a new illustration of 'a majestic vista of an emblazoned sunrise over an enormous futuristic city'. In your head you can see what you want to do, but what problems do you need to overcome to get the painting from your mind to the digital canvas? Thinking through the idea will help you to understand what are going to be the more challenging parts of the piece, most notably the perspective required to encompass the elements fully, the difficult shapes you might need to resolve in the scene and the look you want to achieve, perhaps based on natural imagery. Listing the elements you have for a piece is an intrinsic part of the concept phase. By doing this you are already taking steps in your mind about what are the fundamental parts of the image that must be right. The focal points, framing and compositional balance will all be much easier to control when the problem areas are robustly concepted. The sequence on the next few pages demonstrates the steps you could undertake to create an image similar to *Theistic Dawn* (see page 55 for final image), from the initial idea, through the reference gathering, colour tests and sketches to the finished piece. This illustrates a good method for building up an image based on thematic elements. Use your concept time to solve the particular problems you have – they will probably differ from mine.

Step 1: Collating and sketching ideas

If you are going to start work on an image with a complex composition, dramatic perspective, challenging shapes and believable lighting conditions, you will need to think about what you want to achieve from the outset. Work out clearly what challenges are ahead and how you want to tackle them. Sketch out ideas to clarify the cornerstones of the piece and collate reference material if you feel nature or other art will help inspire you. Here I have illustrated how these elements could be brought together to help form a cohesive direction to move in with the image.

The semi-warm colours in this photo give a good impression of light striking the damp morning trees, giving a strong silhouette.

Taken just before sunrise, these colours encapsulate the look I want in the final image.

There is nothing quite like a tranquil sunset; this image is a great reference for the shapes of the trees and the colours of the sky.

Warm sunlight peeking through the cool clouds on a late autumn day. Very close to the colour concept again.

These tangled trees and shapes mingled with the frosty ground help show how the closer features might be illustrated.

Idea for the curve of the arch – note that it is slightly pointed at the apex in this drawing.

There are many things you can get from nature, but in this piece there are some elements that are purely imaginary. This rough sketch summarizes what I am after compositionally, and is enough to use as a rough to move on with.

Step 2: Drawing out the composition

After some thinking time, draw out some perspective construction lines and start to piece together the main thrust of the composition. At this point you can also start thinking about the colour palette. I wanted this image to be at sunrise, but was thinking about making it a balance of cool and warm tones. Spend some time considering how things are going to work, trying out different compositions.

Step 3: Flipping and colour washing

Flipping the image is a great way of seeing how the composition is working. In this case it was to measure how well the structure had been drafted. As you can see here, I have trimmed the composition, right and left, feeling that it might be better to focus more on the tower than the landscape. Experiment with different colours to alter the look and feel of your piece – keep things loose with your tonal tests.

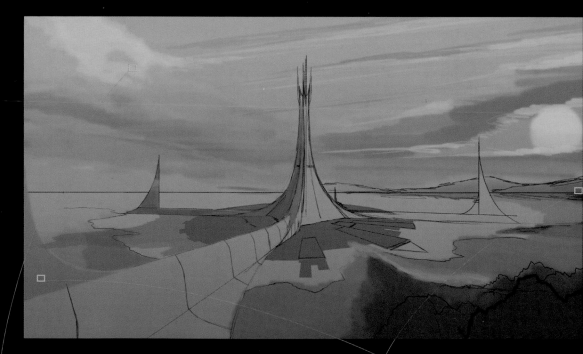

A warm-toned colour wash has been applied, but the intention is to have a cool sunrise.

The narrower image has some merit, but after a while it becomes apparent that the image will look better with extended width to really emphasize the enormous shapes.

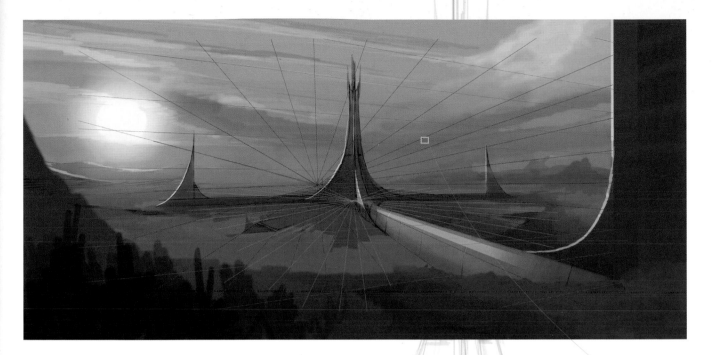

Step 4: Cooling down the colours

Here, the image has been flipped back, and re-extended past its original dimensions. I have also added some important silhouette framing to the left and right of the piece, which will control the composition if the large arch is added. I have begun to cool down the colours, but there is more work to do on this.

Cooler colours seem to work better but could be difficult to balance, so the collated concept work will come in useful.

Step 5: Profiling the arch

If you are adding large or dramatic elements to an image it is sometimes useful to draw out a few iterations of the idea in profile, so you understand exactly what you want to do with it in the more complex perspective composition.

Note the smoothed-off arch shape now.

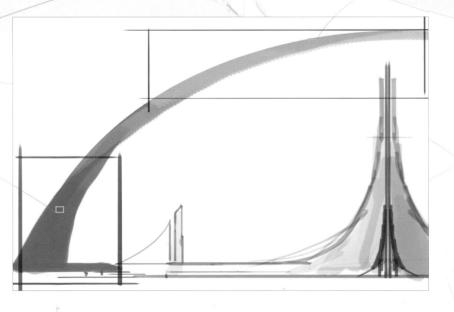

The base of one end of the arch will be behind the viewer up-close and the other end will be just past the towers in the distance.

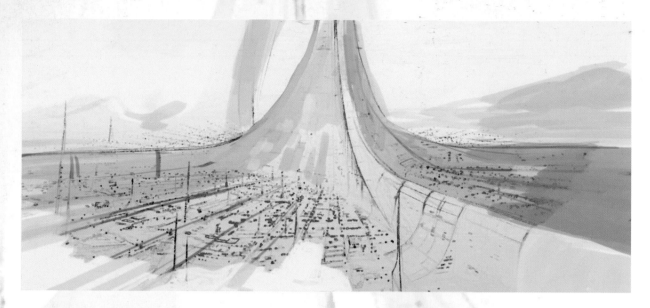

Step 6: Beginning the details

Now start to sketch out the details. Here, I did a quick pencil sketch of a city over a printout of the early line drawing, then brought this back into Photoshop to add shading. If you want some time away from the screen, this allows you to sit comfortably and play with ideas on your lap.

Step 7: Working up the details

Actually working up the detail of the city might take you quite some time. Running at the high resolutions needed for print means you can find yourself adding little nuances and features for a number of hours. The end result will be worth the effort, though, and you will know when you have enough there.

Note the little craft flying over the city – and the millions of lights!

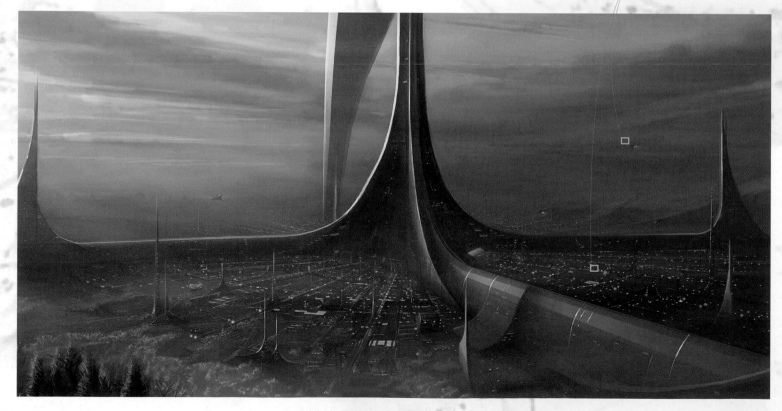

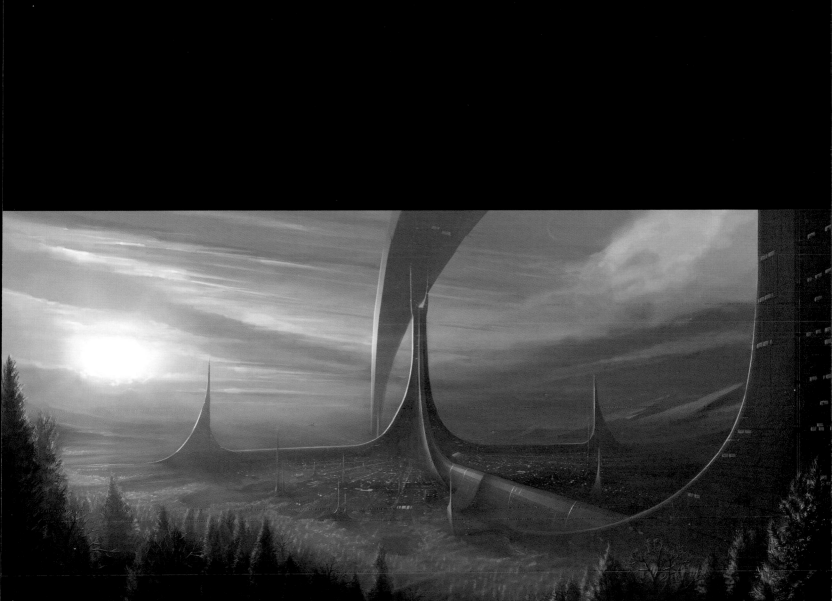

COMPOSITION, FOCAL POINTS AND FRAMING

As an artist, it is paramount that you allow the most important part of the image – the focal point – to be easily read. Here, three images have been analysed to illustrate how they are assembled. Some of the details pointed out may not look that important to the piece, but without them a great deal of the compositional balance would be lost. Establishing the focal point is primary to any good illustration: you need to know what you want the viewer to focus on. However, without adequate framing, balance and lighting, the composition could easily become muddied, ruining a picture. Try to find a harmony between the focal area of a piece and what is in the image to support it. These images illustrate that theory.

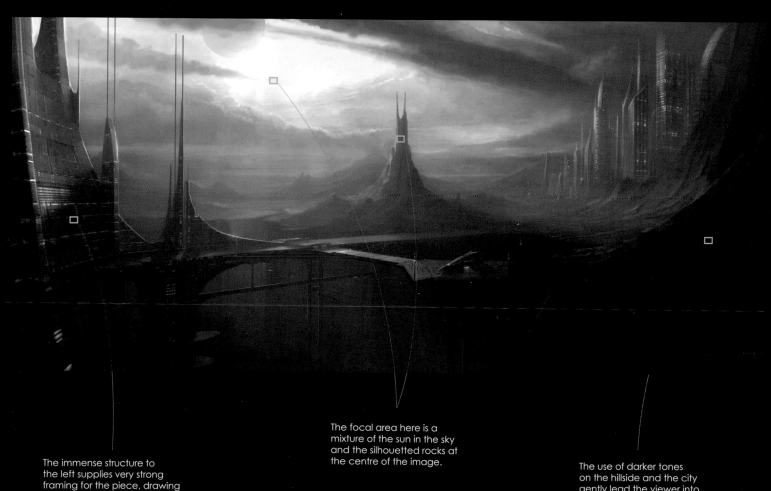

The immense structure to the left supplies very strong framing for the piece, drawing the eye towards the centre.

The focal area here is a mixture of the sun in the sky and the silhouetted rocks at the centre of the image.

The use of darker tones on the hillside and the city gently lead the viewer into the piece.

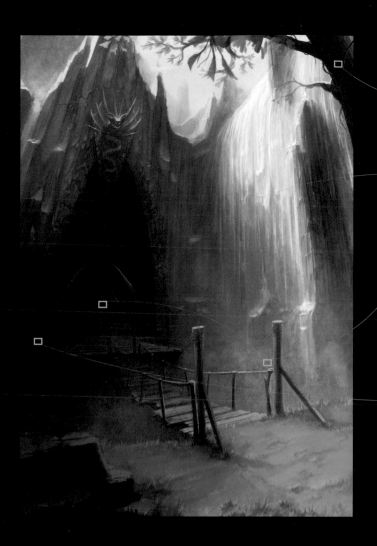

The darker tree adds framing to the right of the piece.

A secondary focal point is the waterfall and the cascading effect of the water, so your eye follows it down the image.

The focal point here travels a little bit, drawing you first to the start of the bridge and then across it towards the dark shape of the dungeon entrance.

The focal point is framed to the left by the dark and damp walls of the dungeon entrance.

The focal point is also the brightest part of the image. The eye is led by the light rays towards the bright centre.

Dark clouds to the left of the piece help create depth, but also hem the bright star into place.

Other stars may look randomly placed, but they are not. Each one helps solidify the focal point and adds depth.

Adding natural shapes such as sweeping clouds draws the viewer into the piece; the eye follows the shape of the clouds through the image.

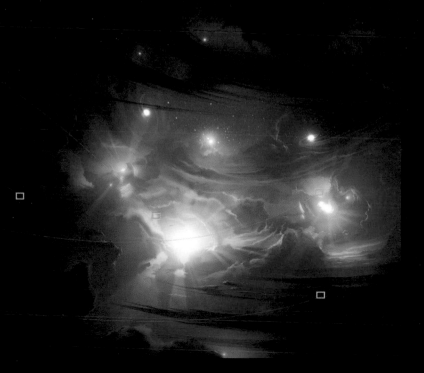

SCALE AND PERSPECTIVE

There are very few things that are more important than achieving strong perspective and believable scaling, especially if your piece contains a number of complex elements of diverse sizes and positions. Failing to get scaling right can undo the illusion of believability an image has, for instance making a human appear too large or too small for a space, or not adequately explaining how diverse shapes work together. Perspective errors can be just as damaging; parts of the piece can sag and flow incorrectly, causing reading errors that make the image unpleasing to look at. Take extra care when projecting your artistic vision to ensure you absolutely nail these two rules and you will find much of the composition will fall into place. Once you have part of the image working, it will create a guide for the remaining parts of the piece. The images here demonstrate some of the things to look out for when working with scale and perspective.

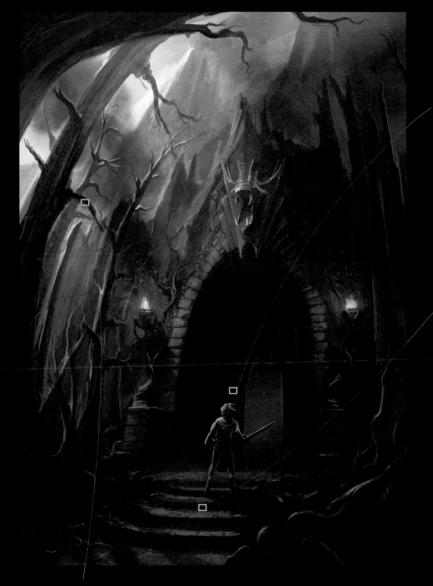

A character approaches a foreboding dungeon entrance; everything around the entrance seems to be closing in around him.

The stairs leading in here are more than just the ground; they literally lead the viewer's eye into the dungeon, stopping at the apprehensive character.

The positioning of the character is the main scale reference for this image. Having him in this position states the scale for everything around him (as the viewer instantly understands the size of a person).

Twisting trees can be difficult to represent while keeping cohesive scale and perspective, so be sure to show definite fall-off in size as they get further away.

While the red (Z) and blue (Y) perspective lines are straight, the green lines (X) bend to give an impression of lens shape. This adds a controlled amount of 'visual error' to the piece, which sometimes helps to make things feel less sterile.

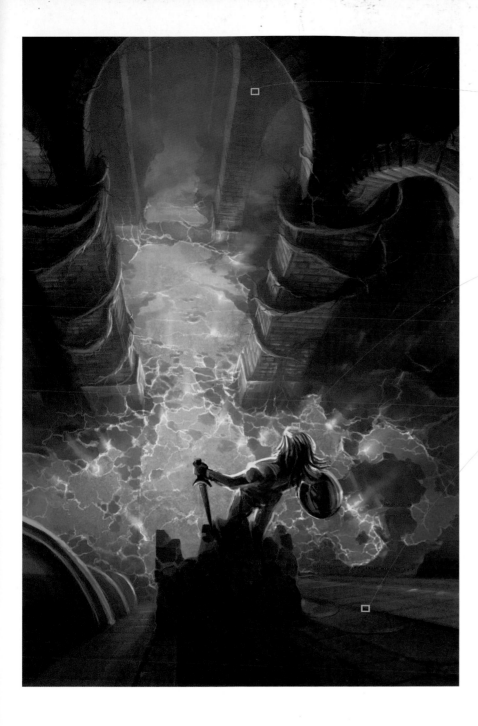

The arches and columns falling away into the lava are placed to add to the feeling of depth and scale. They also lead the eye into the centre of the piece by creating an effective silhouetted frame in the corners.

The position of the character in this piece is designed to add scale, depth and a feeling of vertigo, so quite a lot hinges on him being resolved correctly. He is a strong focal point.

The dramatic depth effects here are created by having the wall fall away from close to the viewer. Lines of brick are used to show the aggressive perspective.

For this piece the only perspective construction lines that are straight are the blue (Z) ones. The pink (Y) and green (X) lines are both curved to show the lens bend, very dramatically in the case of the green lines around the character.

PAINTING A CONCEPT PIECE

Illustrating a concept is all about expressing to a viewer what you intend a structure to look like, the shape and speed of a vehicle, the clothing and stature of a being, or the mood of an environment. Whether your ideas are photographs, sketches, notes or an amalgamation of these, combining them together into a cohesive piece or collection of images is the goal. What you have read so far should help you greatly to structure your compositions, control the perspective, work through any difficult or challenging parts of the piece and finally choose the best possible lighting and colours for a believable end result. On these pages I have shown the steps I worked through to create the piece *The Room* so you can see how the painting was created.

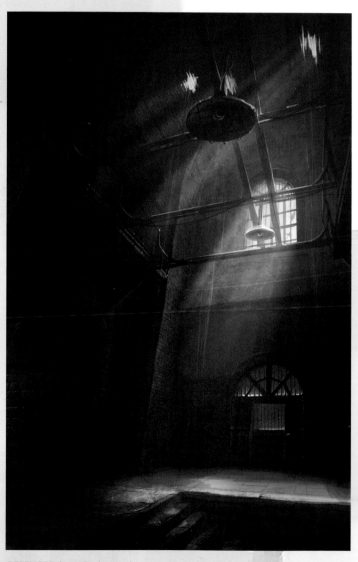

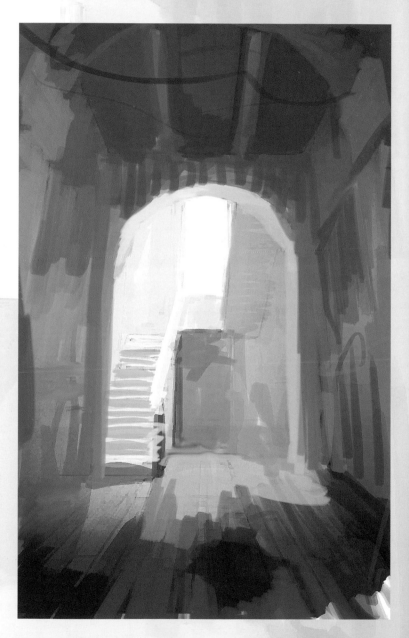

DERELICT This earlier image is a good example of the look I was aiming to project; the atmosphere is certainly similar and the dampened colours are in place. This sort of 'sequential refinement' is helpful when working up ideas – paint an image, see what works and then create a new painting with the lessons you have learned.

Step 1: Starting off

This speed painting was quickly worked up to give a rough impression of what I wanted to convey. This image took about 15–20 minutes and helped me establish what I wanted to have in the piece. Note that I was thinking of having holes in the floor.

Perspective construction lines were added to the top layer and then locked.

Step 2: Beginning the full illustration

Using the rough sketch on a layer and alternating its visibility, quickly create some perspective lines that will form the backbone of the image. Interestingly, on this piece the speed sketch (see step 1) was pretty close to what I wanted, barring the lines of the mid-distance arch. The early brushstrokes you add should be tighter than the sketch.

Step 3: Adding the focal point

This image will hinge around the light coming from the window up the stairs. The idea is that the light leads your eye towards it, but the feeling is that there might be something there you don't want to see. The position of the window is vital to establish it as a strong focal point, which is also the only source of direct light in the whole scene.

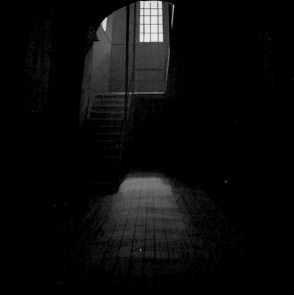

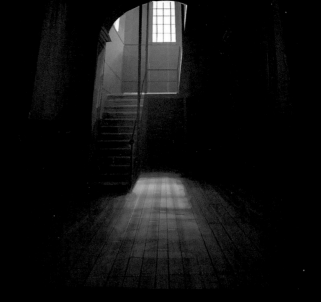

Step 4: Adding initial details

Here I have started to add a little detail in the form of dirt to the floor, ceiling and walls, although there will be a 'noise pass' (see step 6) before real detailing starts. Drawing in the arch more clearly will also start to bring the image into form, as the curves of the arch help greatly with scale and perspective.

Step 5: Fixing the composition

Adding a little to the base of the image has nailed the focal window and really drawn the eye into the piece, starting at the floor in front of the viewer and moving towards the lit floor under the window. Little changes like this can make all the difference to a final piece, so indulge a little and try out different ideas. Adding a tiny bit of atmospheric light from the window is the start of underlining the focal point.

Adjust the Layer Properties to achieve the effect you want out of the overlaid image.

tip – Adding texture

If you are creating an image that requires a certain type of atmosphere, such as a dirty or damaged look for instance, it can be very hard to work a textured feel into your brushstrokes as you paint the image. Working with digital layering enables you to choose a separate image, or images, and drop them on top of your work-in-progress image. By adjusting the Blending Mode and its Opacity in the Layers palette you can find a balance where the layered image helps add texture and interest without damaging the underlying painting too much.

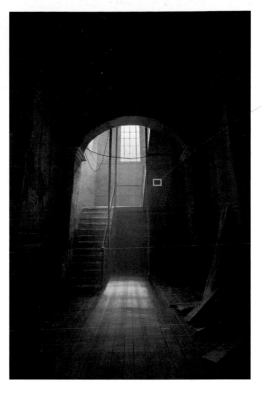

This 'noisy' image of concrete was used as a basis for the dirt detailing. Layer this image on to the main image at around 10–20% Opacity, then flatten.

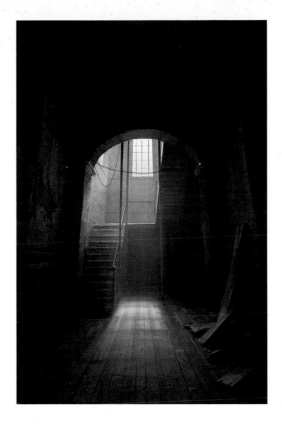

Step 6: Performing a noise pass and adding more detail

This image requires a rustic, distressed look, and much of that will be accomplished with careful detailing. However, before you start the serious detail work, find a 'noisy' image, and drop it on to a layer above the main paint layer at between 10 and 20% Opacity. Flatten it back down on to the image and then use the noise as a base for the distress detailing.

Step 7: Working up details

When detailing an image that requires a distinct look and feel (in this case a feeling of dirt, grime and a thick atmosphere), think carefully about how you want the materials to work. In this image, features such as the tiles on the wall, the dusty wooden floor and the cracked plaster walls all need representing believably. If you are unsure of how to achieve this, do some research to visualize how the elements should work, referring to photographs and using paint tests on a separate layer.

The texture for this floor is built up of lots of light brushstrokes (with a hard brush) following the grain of the wood. After a while you will see the texture appearing.

Once you have the grain in place, start adding the little details that illustrate detail, like the lumps of debris on the floor, including a little shadow cast by them on the floor.

Wall detailing is all about understanding how the wall is made up. Here the cracked render reveals the old wooden slats that would have been used behind plaster in the past.

The tiles here have slightly stronger tonal appearance to show they are not made of a matt material.

Step 8: Creating a diffuse atmosphere

A pivotal element in this piece is the focal window and how the light cascades from it on to the floor. Additionally, this room has a thick atmosphere with lots of floating dust and other particles. To illustrate this effectively you do not need to draw a lot of dots; rather, use a large soft brush with a light colour to brighten the area of the image between the window and the floor – in the direction the light would be travelling. This will give an impression of light actually in the air.

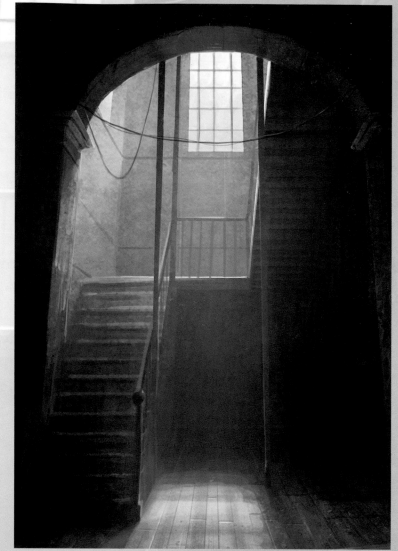

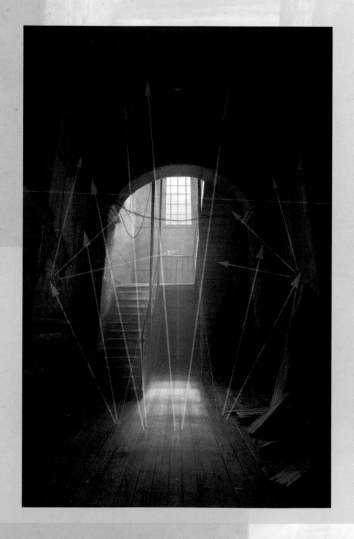

tip – Follow the light

If you are wondering how you should light elements in a scene or how bright the lighting should be, try imagining the lighting lines that move through the image, bouncing off shiny objects quite cleanly, but scattering when they strike something less polished. If you look at this image you can see that I have calculated that the light from the window would hit the floor and bounce (being scattered and diffused somewhat) up on to the walls and ceiling. Some of the light would bounce again off the walls, albeit very weakly the second time. You can then see why I painted the features in the scene the way I have.

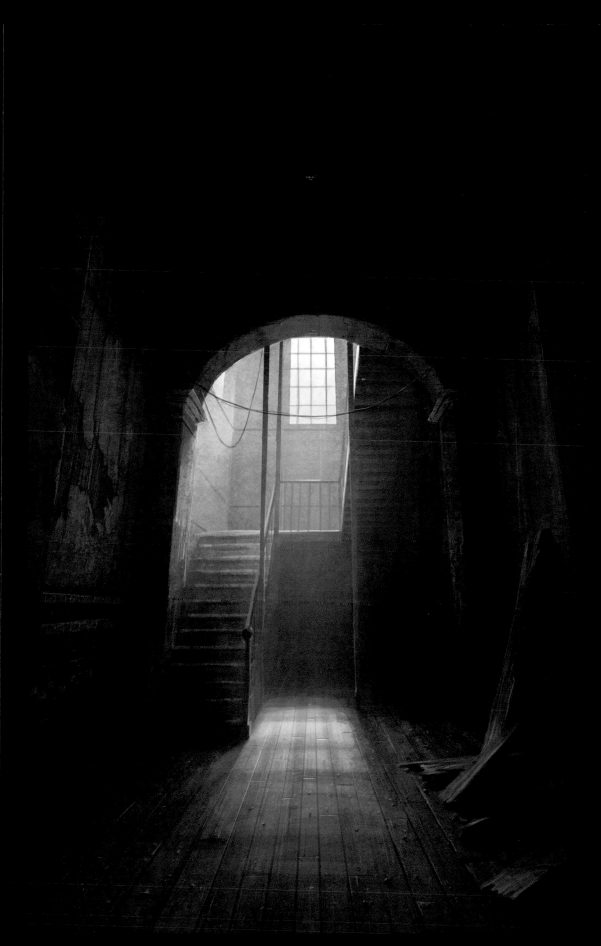

Step 9: Final image

The final image shows a number of extra features that have been added as detailing progressed, such as the hanging light on the ceiling and substantial extra work on the ground and walls to bring the whole image to life and to tidy things up. Looking over the image, it is worth noting that little features such as the hanging wires, dust on the floor, the leaning planks of wood and the cracking and degrading of the walls all combine to create an ominous feeling, full of depth and interest. The light from the window has a 'living' feel, brought about by the glowing shaft of luminosity from the window to the floor. Atmospheric enough? Sign and save it.

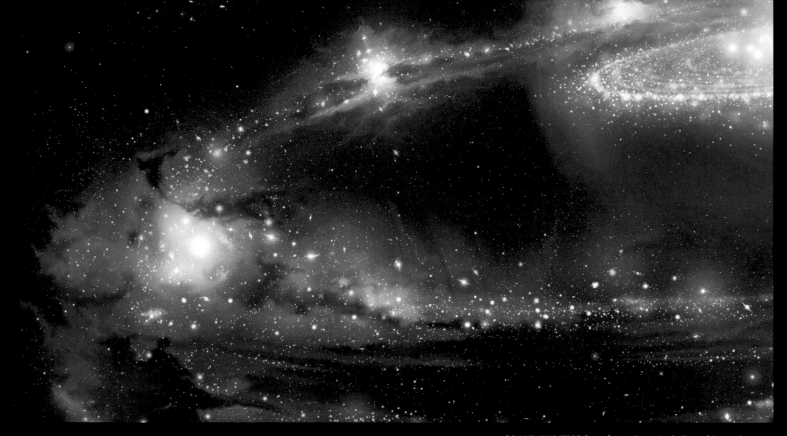

GRAND UNIVERSE (crop) Another depiction of the universe.

Textures and Special Effects

As you become more proficient with digital illustration, you will soon discover just how powerful the tools in paint packages are at helping you to add texture, light, special effects and colour tweaks to your images. In traditional painting, if you place a red brushstroke on the canvas it will always be red unless you paint over it. With digital painting, you can change colours, effects and textures quickly and effectively, thereby greatly speeding up the creative process.

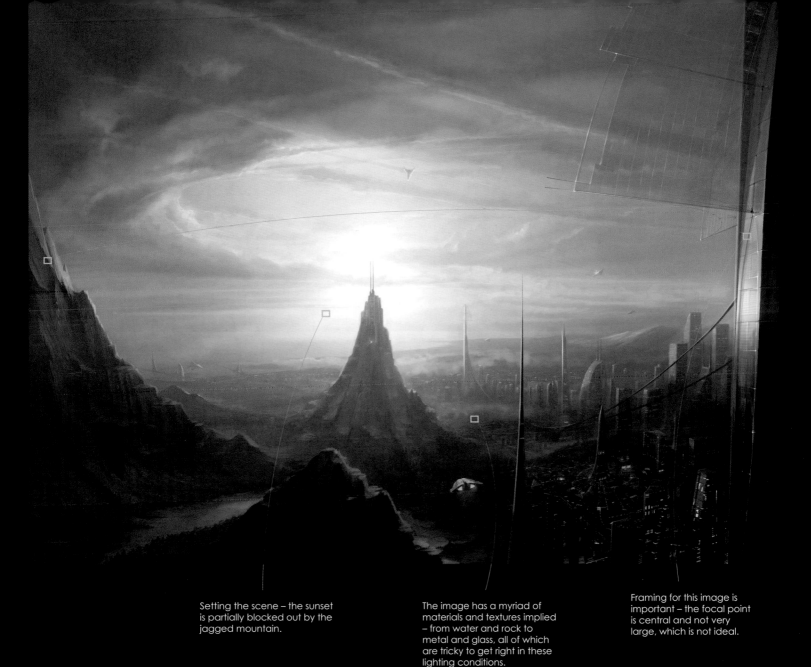

Setting the scene – the sunset is partially blocked out by the jagged mountain.

The image has a myriad of materials and textures implied – from water and rock to metal and glass, all of which are tricky to get right in these lighting conditions.

Framing for this image is important – the focal point is central and not very large, which is not ideal.

TEXTURES

Creating fully formed illustrations that describe shapes definitively, and that conjure up a strong sense of depth, perspective and believability, requires a good understanding and control over all the aspects discussed in the preceding chapters. The final level of credibility is created by ensuring that your scenes feature materials and textures that behave in the correct way. You want your shiny objects to reflect light correctly, your rocks to look sharp and hard, and your clouds to diffuse the light in a way that the viewer can understand. Obviously, with all the potential materials in the universe and those from your own imagination, it is not possible to cover them all here. However, over the next few pages I have explained how to achieve certain textural and material effects using an analysis of my painting *Basilica*.

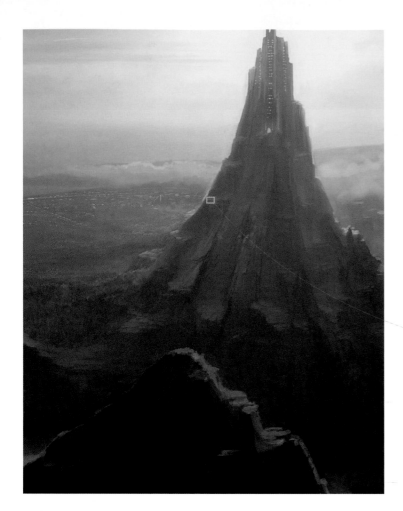

NATURAL MATERIALS

Much of this image relies upon the marriage of many natural elements, such as the mountains, water, clouds and the powerful lighting set-up. When you are painting materials like these, try to understand how they might behave. For instance, rocks are usually matt in nature (unless they are wet), so they will be relatively dull in diffuse light, which these two mountain shapes are. Likewise, the many trees up the mountain sit in harmony with the rockfaces in the diffuse light. In direct lighting conditions, trees and plants take on a more complex appearance, with subsurface scattering (glowing when lit from behind) and other features.

The surface of the mountains appears dull, except where the sides are catching direct light from the setting sun, picking out some nice sharp edges.

Here, the light bounced from the sides of the building is slightly matt, but brighter than rock.

MANMADE MATERIALS

Materials such as concrete, glass and steel behave quite differently from grass and rock, although concrete does have some similarities to certain types of rock. The key to making these materials feel balanced with the rest of the illustration is to allow the lighting and atmosphere to draw all the elements together. That being said, the representation of concrete would not be like rock – you would expect it to be mostly without flaw, although with some mottling and texturing. Likewise, metal surfaces will reflect light beams back more efficiently, but not to the extent that glass does.

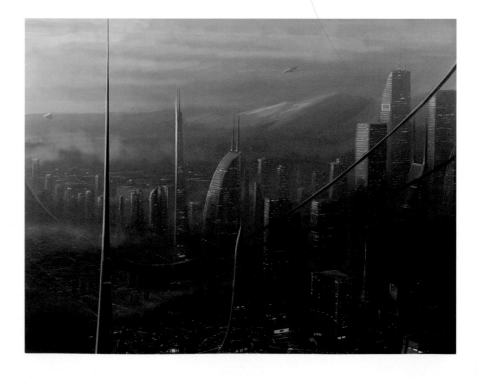

GLASS AND REFLECTIVE MATERIALS

Glass is an interesting material to work up. It does not have a texture of its own per se, but rather takes on a look dependant upon the surrounding objects, colours and lighting conditions. To deal with glass appropriately, it is best to imagine that the position of the viewer is the start point and the glass is like a deflector. To draw what you need in the glass, imagine a line coming from you to the deflector and then outwards again. The object you hit should be mirrored and painted. Obviously, the strength of the reflection depends upon how acute the angle of view is and the type of glass you are painting, unless it is mirrored (or one-way) glass, which reflects from any angle.

The sunset and other buildings are reflected in the glass.

Water is reflecting the mountainside behind it, but not clearly, implying a degree of turbulence in the water.

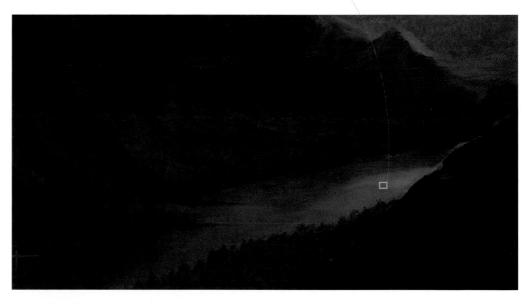

WATER

Much like glass, water has the ability to reflect nearly perfectly, if the water is illustrated as calm and the angle of view is acute. However, as the angle becomes less acute you would expect to see more of what was under the water and a less intense reflection. Additionally, if the water has movement you would get a much less coherent reflection, with pits of darker tones and peaks of highlight, depending upon lighting and angle. In order to portray water with any degree of believability, I would strongly recommend making a detailed study of water both from photographs and in nature.

TRANSPARENT MATERIALS

Describing transparency can be problematic: if it is done too accurately, it simply looks as if there is nothing there. The key is to add at least a small amount of inaccuracy to let the viewer understand what they are looking through. Clouding, darkening or lightening the objects behind the translucent material also helps to describe the shape better. A translucent object would also pick up a degree of reflection, as glass does, so take this into account when painting the details in.

Note how the shape is illustrated here by light transference errors, irregular glass panels that refract the light slightly differently from each other, and the odd bright highlight.

LUMINOUS SHAPES

The ground level of this piece is already in shade so the manmade lights on the buildings down there can easily be seen. Adding glows to windows and dotted lines that represent roads helps to imply a living world containing many people. Be careful when adding these sorts of lights and glows that they balance well with the surrounding objects (striking them with light if they are bright enough). Also take into account the distance these are from the viewer, as atmosphere will diffuse the lights the further away they are.

Lights in the distance are diffused (compared to the lights that are closer to the viewer) by the clouds and atmospheric conditions.

CLOUDS AND FOGGING

Clouds can be challenging – many clouds you see in nature would not look believable if painted, so be aware of that and don't try to depict anything too fantastical. Clouds should take on the colours of the scene, being made up of an accumulation of a transparent material (water). It is the sheer volume and density of clouds that diffuses the light – in many cases, actually blocking light getting through. Hard highlighting on clouds can work very well, but must be painted with care. As with water, I would recommend much research and sky-gazing to observe how clouds behave.

The ground further back is the same tone as the ground closer up, except for what the atmosphere has diffused and tempered.

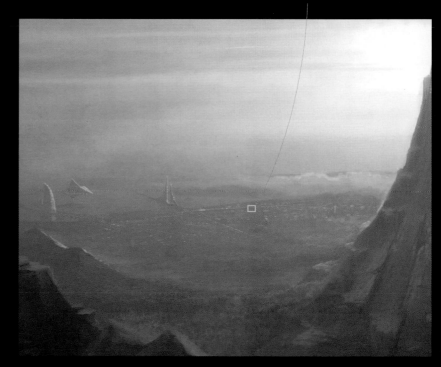

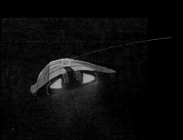

This metal craft picks out the light of the sky on its top and reflects the dark of the ground on its rear.

METALLIC TEXTURES

Objects with a metallic finish reflect light readily, almost as effectively as mirrored glass or chrome. But for the most part, metal either reflects light well, but does not transfer a cohesive reflection, or has been painted (like a car body). Metal that has degraded somewhat may have signs of damage, scarring, dents, dirt and rust. These will eliminate much of metal's ability to reflect, so take this into account when you are painting materials like this. Metal is just as adept at reflecting the dark as it is the light, so metal with no diffuse light on it will appear quite dark.

ATMOSPHERE

Any type of atmosphere, whether on this world or another, will affect the appearance of objects, depending upon their relative distance from the viewer. What generally happens is the steady accumulation of the ambient colouring and tones from what is at that distance. The further away objects appear, the more they seem the same. This is always progressive, unless there are other volumes of diffusion (such as clouds or localized fogging) that will diffuse objects blocked out by them.

textures and special effects

7

SPECIAL EFFECTS

Computers have revolutionized the film and illustration industries by allowing expressive and exciting visions to be visualized more quickly and more cohesively. In no arena is this more evident than in special effects. Many contemporary films have amazing – and seamless – special effects, and this ability has become possible in the world of illustration too. Working with digital paint allows you to try out different ideas and effects rapidly, on separate layers or with copies of your original art. This ability alone can make an artist braver and feel more at ease with experimentation, the cornerstone of true artistic expression. The myriad of layering modes and brush effects and types in a program like Photoshop makes it practically impossible to list all the potential effects. However, I use some of these effects and brush types to add extra depth and drama to my work from time to time, and I recommend that you do your own experiments to see what can be achieved. In the next few pages I have listed a few of the more interesting effects that you can apply to layers and brushes to add light, shadow, texture and depth. You can then go forward and play with these modes to achieve a look of your own.

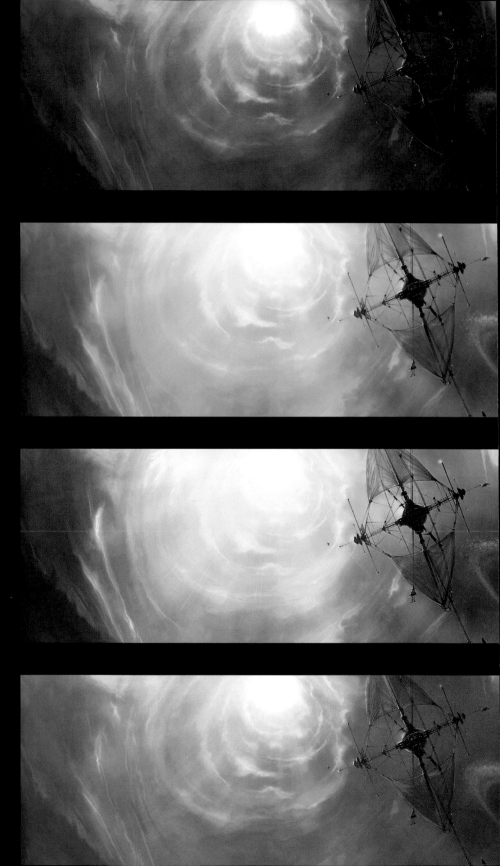

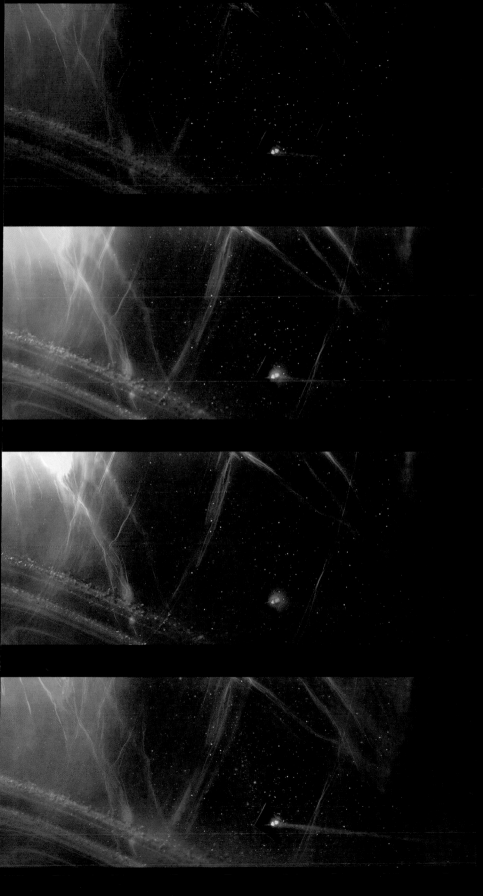

A crop from the image *Outpost* (see pages 38–9 for full image) showing the tonal and hue range of the image. This is the unaltered image.

Here is the same portion of the image after it has been through a pass in the Hue/Saturation control, selecting Colorize and shifting the hue to a green/blue colour.

Here the Hue/Saturation control has been used again, but this time the image has been altered by shifting the entire hue range 180 degrees away from where it was. The look is dramatically different, shifting the spectrum of colours so purple becomes green and blue becomes orange.

In this instance the image has been run through the Curves menu. This time I have placed some simple controls on each colour channel, upping the ramp on the red, keeping the green the same and dropping the ramp on the blue. See how much brighter the image feels, and how much warmer it has become now red dominates.

BRUSH EFFECTS

On these pages I have illustrated a few screen shots – revisiting *Basilica* again to show how some of the brush modes I use affect different areas of the piece. As you can see, a lot of these brush modes are useful for creating glows and shadows. Used subtly, they can be very good at bringing tones together or reducing unwanted contrast levels, or indeed adding extra contrast to certain areas.

COLOR DODGE

As you can see here, the brush has been positioned over the lit doorways of a building in the city. The Opacity of the Color Dodge brush is set quite high and the colour was gathered from the bright green of the lit doorway itself. The end effect is far too bright (for illustration purposes), but you can see that the Dodge has created a glow-like area around the doors. Used more carefully, this might look quite good.

This effect is too bright here, but it could be useful if applied with more finesse.

LINEAR DODGE

A similar pass was made here, with the same Opacity and, most importantly, colour. The Linear Dodge tool literally multiplies the RGB value of the incoming brush to the targeted area, creating a much more dramatic rise in vibrancy, even though the brush scale is set lower.

This effect would need to be used with more care, but Linear Dodge can be very useful for adding a glowing effect to an area – just keep the Opacity down to avoid overkill.

HARD LIGHT

This mode adds the effect of a light being placed over the selected area, so you end up with a more subtle effect using the same settings. I have used a greener colour here, but the Opacity is still high. This effect works better without too much adjustment, but you can see the dramatic difference between this mode and the Dodge tools on the previous page.

COLOR

This mode is related to two others in the same group: Hue and Saturation. Color combines these two other effects to bring the target towards the actual colour of the chosen brush. As you can see, there is a non-too-subtle swathed stroke across the right of the screen. The brush is set to 90% Opacity so it has drawn all the tones of the image towards the deep blue colour.

A green glow – very sci-fi.

Using Hue would only shift the spectral facet of the colour, leaving the saturation intact. Using Saturation would only align the saturation of each colour, leaving the hue unaffected.

VIVID LIGHT

Here, I have used a fairly large brush over the area at the centre of the piece using a bright yellow colour. As you can see, the effect is an instant burning of the colours, giving the impression that the sun is much, much brighter than before. Used more carefully, this effect could gently lighten the setting sun and the surrounding area to draw the eye more towards the focal point, for example.

From sunset to supernova – arggh, my eyes! Used gently though, very good light effects can be achieved.

LAYER EFFECTS

The layering system in Photoshop is extremely powerful and versatile. It can simply allow you to create a safe place to try out new ideas without affecting the rest of the image, or it can be used to add dramatic effects and glows to your images. Text, textures, and anything else you can think of can be added on to additional layers, which can all have effects applied to them. It would be impossible to show you all the layer effect possibilities here, but I have broken *Basilica* up into nine parts, and have applied a different effect to each section to demonstrate a few of the many options available to you. Each part has had an exact copy of the background layer on it, but at 50% Opacity to prevent it overwriting the underlying layer. The layer modes in Photoshop mirror the brush modes (see pages 74–5), so once you learn how they work in brush mode, you will understand what to expect when using the same effects on layers. Above all, do not be afraid of experimenting with these effects – just dive in.

MULTIPLY: Will always result in a darker image; the amount is determined by how bright the overlay is. The darker the original colour is (the dark parts of the clouds here), the more dramatic the drop in vibrancy will be when it is layered on to itself.

SOFT LIGHT: This is part of the Light group of effects, specifically lightening or darkening colours depending on the overlaid colour. If the overlaid colour is more than 50% brightness, it adds a diffuse light effect of that colour on top of the image; if darker than that it subtracts the same colour. See how it has generally darkened the colours, specifically in the silhouetted mountain.

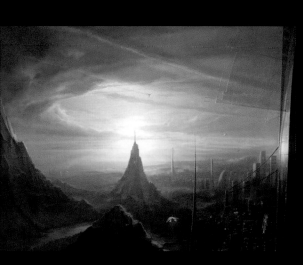

BASILICA Original image.

COLOR BURN: As you can see, this is dropping, or burning the vibrancy of the pixels by increasing the contrast. The darker the overlaid colour, the more impact it will have on the pixels beneath. Note the dramatic darkening of the clouds.

LINEAR BURN: Like Color Burn, this mode drops the colours of the target pixels with the brightness of the overlaid ones. It differs from Linear Dodge in that it drops the brightness relative to the overlaid colour, creating a smoother and less vibrant result. Note that all the colours are dropped more consistently than Color Burn.

VIVID LIGHT: This is quite a new feature to Photoshop. It uses the same principles as the other Light modes with regards to how it makes decisions, but uses Burn and Dodge as its effects. Notice how aggressively this has altered the colours and the contrast, specifically on the windows (bright) and the buildings (dark).

HARD LIGHT: This behaves like a coupling of the Screen and Multiply modes, depending on whether the overlaid colour is 50% vibrancy or lighter. Notice how this has created a brighter and more contrasting look to this area.

SCREEN: This works in the opposite way to Multiply by always lightening the area, unless you overlay black for example. Note how, in this instance, it looks very similar to the Linear Dodge effect used in the adjacent part.

LINEAR DODGE: Like Color Dodge, the effect is aggressive – you can see that it has stretched the tones greatly towards the darker part of the range. Note the darker part of the hillside.

Humans and
Other Beings

What would fantasy art be without the innumerable beings that can be depicted, whether they are based in reality or completely imagined? The creation of new and interesting characters is an enormous attraction for artists; many want to hypothesize on how these life forms may have come into existence, and those who enjoy painting fantasy worlds have the opportunity to conjure up the environments in which they could become 'real'.

The unique aspect to creating human-like or beast variant art is the incredibly deep sea of imagery we have in our world to inspire us. From the people you know, to the creatures you see in your garden, there are endless ideas in nature from which to create incredible beings and beasts, bestowing upon them magical powers, flight, beauty, aggression – anything you can imagine. Many of my artist friends spend endless hours working on beings like this. Although I do not dedicate as much of my time to this discipline as I would like, I find their visions of unexpected and exciting creatures and people fascinating. This chapter is about finding an interesting way of projecting visions of living beings, and the images here illustrate that challenge beautifully.

SPIRIT RISING A female spirit rises from the city far below.

WAX DRAGON An amazing 'beauty and the beast' image, painted by the unique Natascha Röösli.

ZOMBIE VIKING An incredible creature concept by Kevin Crossley.

TOO SWEET Another enchanting and enticing image by Natascha Röösli.

TRANSPORTING A REAL FIGURE INTO FANTASY

Although I enjoy painting the human form, I find originating poses quite laborious. Working from photographs can be a speedier solution, so I was very pleased to find this amazing model shot taken by a friend, who works under the name Darkmatterzone. I have edited the original photo as it was a nude, but the pose is very close to what I was thinking of for a new painting, and was a great source of inspiration to me. This, along with other references, helped me to create this evocative piece, entitled *Stormbringer*.

Step 1: Making a rough sketch

Using the photograph as a guide, start to sketch out roughly how you want the figure to be posed. The angel's basic pose is close to that of the model in the photo, but I wanted her to be taller, thinner and longer-legged. I also want to 'flight' pose the feet, back and other details. I chose a different pose for the arms (the photo posed a near tangent from right hand to left arm, for instance). The final touch will be a swathe of clothing flying off her and into the clouds. Using clothing like this can be highly suggestive, which will make the picture more alluring, plus it will add movement to the subject.

Step 2: Blocking in tones

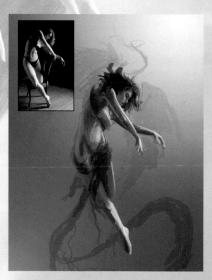

Start to paint in the block lighting and shadow work across the figure's body. Try keeping the photo reference visible on another layer; this way you can refer back to it with ease if you find you are struggling while painting details. Keep your strokes quite rough but try to place important details correctly. The human form is very easy to get wrong, so keep referring back to your photograph, or to anatomy books, while working.

tip – Keep loose when sketching

When sketching out ideas, try to keep an enjoyable, loose approach going. Don't immediately start trying to add definitive lines and shapes when you have not achieved the rough proportions or pose you are after. Gently stroke the lines with a low brush setting and a soft touch on the tablet. This will slowly build up the shape over time. When you are surer of the shape you want, start pressing harder to define the lines and describe the subject clearly.

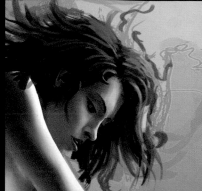

Step 3: Working initial facial details

Faces are extremely complex, so getting the features and expression just right is paramount. Be aware that the slightest nuance or position change can affect the way you read the subject. Create a careful line pass to form the shapes first; then you can move on to painting. I want my figure to be pixieish/angelic in appearance, so fine detail is necessary on her features. Start to add the colouring and tones for her face gently, paying very close attention to how her mouth, nose and eyes catch the light. For her hair, try to add a type of motion to it, as if she is floating in the sky. Use rough strokes to start with and then look at honing them into detailed hair later on.

Step 4: Blocking in the skin tones and clothing

Once happy with the face, your confidence levels should be high enough to start working down the body of the figure, adding to the detail of the skin tones and the fabric draped around her. An important feature here is how the angel's right arm and left hand catch the light. I am going to add wings to the figure, so I need to remember to take note of the shadows these will cast on her body. The light features will help counter-balance the dark wings when they are painted in.

Step 5: Adding clothes

The angel's clothing is very important in this piece, partly because of its suggestive power, but also how it is going to integrate with the rest of the scene. First, ensure that the position of the clothes helps to augment the angel's physique. Try to make the fabric flow around her and tug in the places that suggest shape (hips, breasts and so on). Create a new layer to do this on, so you can alter the details easily.

tip – Use the dynamic Color Picker

When working with similar colours, such as the skin tones here, once you have the basic light and dark shades about right, use the dynamic Color Picker to choose colours as you paint. Simply hold down the Alt key when in painting mode and click on a colour to paint with it. This will speed up the process of smoothing the tones without the need to open the main colour palette menu.

Step 6: Starting the wings

The angel's wings are intrinsic to how this image will work. As they are going to be quite dark, they will greatly affect the compositional balance. If you choose lighter wings the effect will be dramatically different. Work up the loose wing shapes quickly to see how they work with the rest of the piece. Use a new layer for this, underneath the layer with the figure on it, as you want the wings to appear behind the angel.

Step 7: Working up the background

Although the background for this piece takes second place to the subject, the intention is for the angel to be affecting the sky with her movement. From here on you will need to start balancing her against the sky. At the moment this is a rough tonal sketch of the sky – the aim is to have stormy clouds beneath her. Make sure that you paint this on to the background layer, below all the other layers.

Step 8: Combining the figure and background

You might find you need to perform some alterations to specific details when you integrate the multiple elements together. The first thing I have done is paint a large block of blue sky up and to the right of the angel. This helps silhouette the wings and also adds a nice bright 'draw' to that part of the piece, implying a movement in that direction.

Step 9: Executing fine facial detail

Now all parts of the image have had one pass, work again on the face, tweaking and adding details to the angel's features once you have had time away from looking at them. This is something that can be quite time-consuming, but her face has to be right, with a gentle gaze towards the clouds below. Little details will be added and changed until the piece is finished.

Step 10: Achieving the transition from clothes to clouds

An important aspect to this piece is what the angel is doing: creating a storm. Her loose-flowing clothing morphs into clouds as it tapers away from her. When creating this effect, lay down soft, cloud-like brushstrokes first and then paint the tapers and fabric effects on top of these to ensure a neat join. Try to pay careful attention to how the light catches the fabrics and the flow of the tapers as they leave the angel's body.

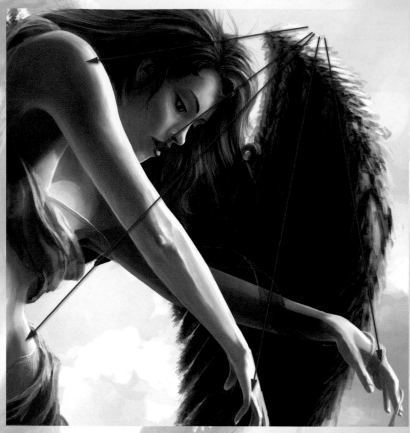

Step 11: Detailing the wings

I pondered for a long time about how to portray the wings. One idea was to have dynamic wings spread wide, but this detracted from the focal point of the piece, making the angel look small and overpowered. Try some different styles yourself and see what works well. In the end, a simple classical wing style worked best. The detail colouring is based on a kingfisher's livery, with purple instead of orange. The turquoise complements the other tones in the painting. The brushstrokes used to form the wings were quite loose and made using a medium hard brush.

Step 12: Painting in subsurface scattering and light diffusion

Scattering and projecting light through solid objects gives them a warming glow, working brilliantly on anything organic such as leaves or skin. In this case you will want to try to give the angel an ethereal feel. To achieve this I used a soft skin-toned brush on a low Opacity setting using Color Dodge and progressively stroked the skin lighter.

Step 13: Painting the feet

If, like me, you find feet challenging, you will want to spend a great deal of time making sure you portray them just right. I used a number of photographic references for this. Be careful to use light expertly to help describe their shape. It's important that they look elegant, almost tapered away from the body, much like the fabric, as this will help give the sensation of an upward movement.

Step 14: Adding close-up details

Adding little flourishes of detail close-up is a favourite task of mine when composing images, so try a few different shapes for the flowing ribbons coming off the angel. I have been tighter with the detailing on these pieces of fabric than most, as it adds some nice detail that is then implied to the viewer in the rest of the fabric. Keep note of how the light strikes the fabric: light is your main ally in describing the direction and rotation of the ribbons.

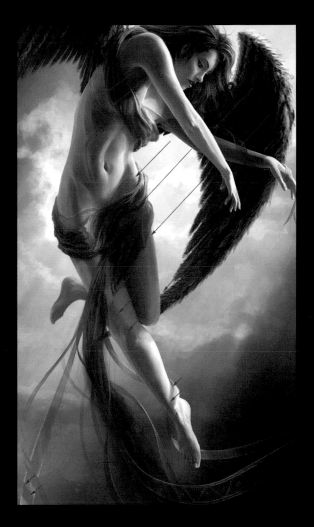

Step 15: Achieving realistic shadow fall

This image shows a breakdown of how you should think about the passing of light through the scene. The light position is above right – slightly behind the angel. The wings drop shadows on to the area below the waist, the fabric scatters light on to the leg, and the wing darkens the left arm, creating depth. You should always visualize where your light will be coming from before you start on the detailed brushwork.

tip – Think carefully about where to place light sources

Careful and creative placement of lighting in a scene can transform the most mundane subjects into exciting studies. Conversely, badly placed lighting can remove the potential for depth creation, shadow definition and shape emphasis. Think long and hard about how your lighting will affect the scene. Very deliberate positioning of the light source in this piece allows the subject to capture light to great effect (red strokes) and dramatically block the light to create depth-inducing shadows and strong silhouettes exactly where I want them (blue strokes).

Step 16: Adding fine hair detail

You may find you would prefer to add detail to a different part of the piece than I have, but here I have been careful to work the hair up more intricately than the feathers on the wings, which I have left quite loose by comparison. This was partly down to time and partly down to preferring less detail on the wings, while I wanted to be delicate with the hair to help describe movement. Use a fine brush for the hair; set Opacity and Size Control to Pen Pressure and then use gentle brushstrokes, following the general direction of your blocked hair shapes, adding detail with each stroke.

Step 17: Increasing hand details

The hands need to be delicate and angelic in nature. Try to work with a reference to get the details just right, as getting the proportions wrong can ruin the whole piece. Note the subsurface lighting again, used to augment the feeling that the angel is almost glowing, and the gentle fabric shape coming off her fingertips, describing movement. Finally, little peaks of light on the end of her fingers and a little artistic rim lighting tidy things up.

Step 18: Final image

The final piece makes certain that the angel is the focal point; her slightly non-human pose and physique along with the fabric falling away give her dramatic movement while the wings punch a shape out in the centre of the piece that draws your eye towards her all-important face and hair. I was tempted to increase detailing to the background, but I decided that it would not add much to the image as the subject needs to stand out. Add a few light rays in the clouds using a Dodge tool, then flatten, sign and save it.

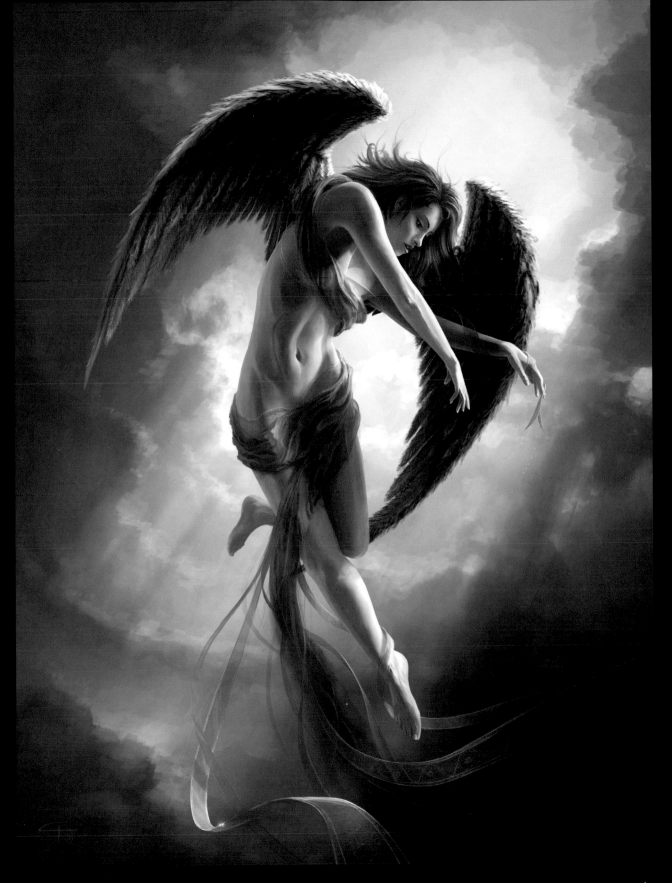

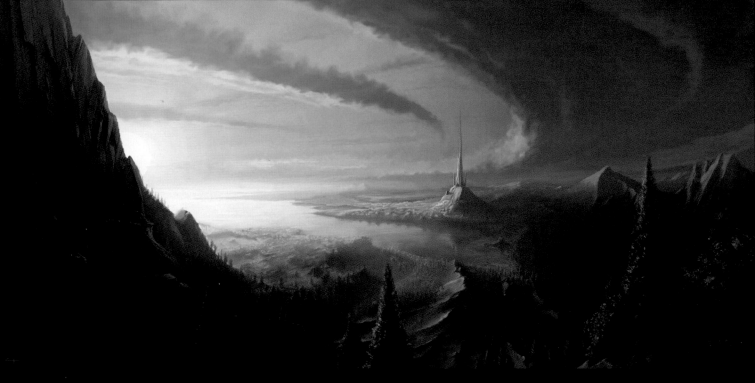

EVENTIDE Sunset in a fantasy world.

Land and Spacescapes

I have always been inspired by the magnitude of what is out there in this unbelievable universe. My fascination for outer space and sci-fi was galvanized by movies such as the *Star Wars* series, but I have also found as much inspiration in looking at the amazing images collected by modern telescopes, or just by gazing at an incredible night sky.

Depicting spacescapes certainly has its challenges. Trying to balance the vastness of subjects such as planets, stars and much larger nebulae and galaxies can be tricky, but it is enormously rewarding to achieve a pleasing composition that encompasses these subjects. Leading the viewer's eye becomes very important when dealing with objects of this vast size. Often, I will work the image up so that it contains two distinct focal points – one large planet or moon that is closer to the viewer and then a much larger star cluster or nebula further away. The key to balancing this sort of composition is to try to illustrate the distance between the two subjects, therefore demonstrating how much bigger one is than the other.

The other area I revel in is fantasy landscape illustration. Creating imagery of this kind can conjure incredible emotion in the viewer, particularly if you can capture the essence of something real-world and add something supernatural, extraordinary or mystical, such as an ominous structure, otherworldly fauna, creatures, dramatic weather or exciting colours.

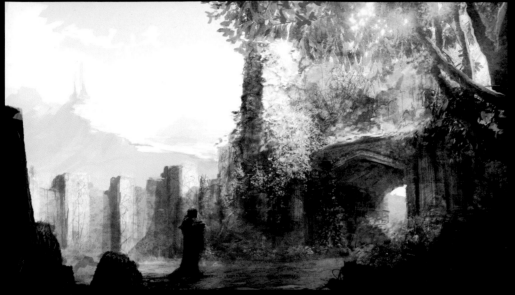

ENVIRONMENTAL A 70-minute speed painting.

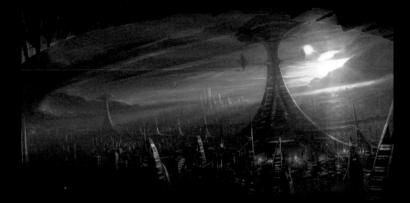

RAEVONA Enormous docking towers pierce the clouds on a distant world.

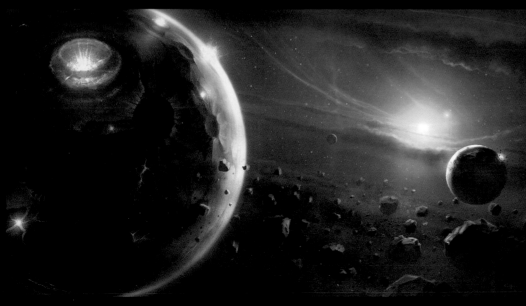

PLANET FORMATION Worlds form within the grasp of a new star.

CREATING A BELIEVABLE FUTURESCAPE

I create a lot of imagery depicting the far corners of the universe, cities, vistas from alien worlds and starscapes. For this piece I thought I would try something a little different and portray our own world in the future – an image of hope and unity that shows what people might experience one day on this world. I also liked the idea that this image depicts people about to embark on a voyage from our planet to see other parts of the galaxy – literally taking a trip to somewhere I would paint.

Step 1: Sketching out the idea

A quick sketch is useful to set in your mind what you want to portray – in this case, dramatic perspective and enormous scale. This image was sketched in Photoshop using simple black and white on the alternate brush colours and then just using the X key to jump between the two as I painted – a fast and fun method to try.

Step 2: Establishing the rough composition

To start with, position your focal point. The craft at the centre of this piece is going to be an enormous space passenger vessel, much like a seagoing cruise ship today. To speed up the process of balancing the composition, try building a simple shape for the craft in a 3D package such as Maya. This is beneficial as you can quickly move the camera around to find the best position. Next, screengrab it and in Photoshop scale the image up to the desired end resolution – in this case, 6000 pixels wide. Now start laying down some perspective lines. The red (Z) perspective lines are created directly from the 3D shape's position, but try using some artistic licence with the X and Y lines to add some lens bend. Small perspective inaccuracies help add a little asymmetry to a piece, and can make for a much more pleasing composition.

Step 3: Setting the craft in context

You need to consider various factors when deciding your context, such as the time of day – which affects lighting – and location. Here I have chosen to depict a coastal city, with clear midday skies. With the craft layer hidden, rough out the initial elements on to the background layer. Here, I wanted an intergalactic port attached to high buildings that tower over the city below. I wanted a terminal building to the left and a hotel to the right. The hotel helps to balance the composition, and I plan to make it reflective in the final painting.

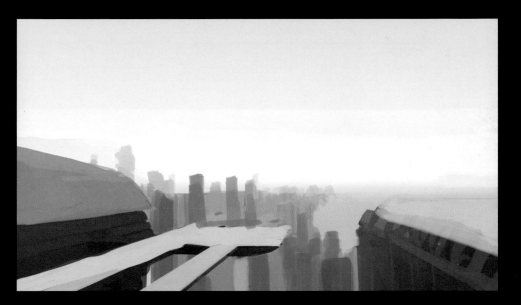

Step 4: Painting in light and shadow

The next step is to start working up your primary light source – in this case, the sun positioned slightly to the right and very high up. Start working up how the shadow of the craft would fall on other elements in the scene. Shadow work is key to creating believable depth and positions for objects. Then flatten the image down so that there are only the background and perspective layers left. Keeping layers down is very important when working on large images, as they quickly eat up memory.

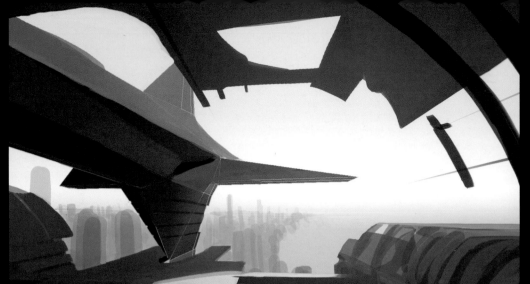

Step 5: Framing and emphasizing scale

The next stage is to work up some nearer shapes to help emphasize the scene's depth and describe the scale of the craft. I added an upper dock in the middle distance and some silhouetted curved shapes closer to the viewer. Create another layer for these, just in case they don't work out, but once happy you can flatten the image again. I want to give the distance an overexposed look, like a photo taken from the shade but with sunlit elements. I am not going to be painting clouds in this piece; I want to depict a clear and sunny day with a faint warm haze in the distance.

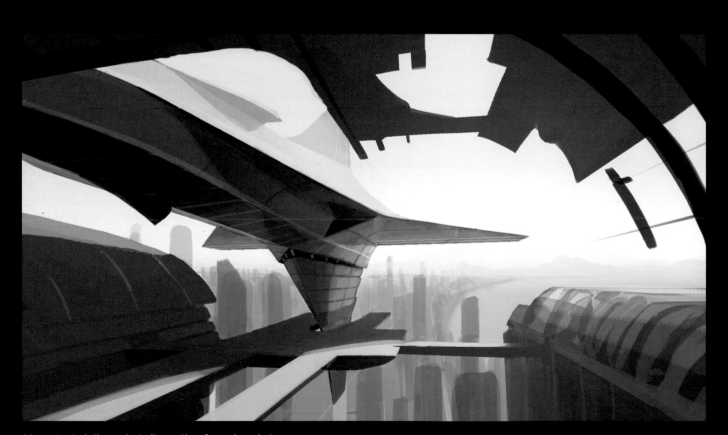

Step 6: Adding detail on the focal point

Next, start working on the craft. This craft will have semi-reflective properties so it will take on some of the colours of the surrounding scene. Focus on the rough lighting for the craft by using the primary source to light the upper wings brightly. Use secondary bounced light to strike the underside of the wings and hull. You may want to try out some extra features on the craft – a fin on the underside and some winglets on the top of the main body, for example. If they don't work very well you will be glad they are on a separate layer – the top ones here don't work!

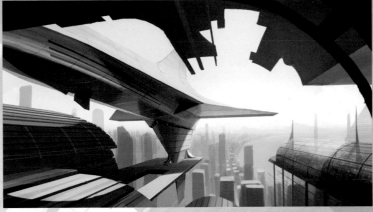

Step 8: Spreading your attention evenly

Don't be tempted to add too much detail too soon. I find that once you start to feel better about a certain aspect of a piece, other aspects stand out as needing attention. I've moved away from the craft and on to the lighting and shape detail in the surrounding buildings and cityscape. You may want to start adding some material detail to the buildings too – in this case to help balance the composition with the focal point. I've added some lower dock shapes close-up to allow me to drop some shadows from the upper dock on to the lower one. This is worth focusing on, as a good image will draw your eye from near to very far away smoothly.

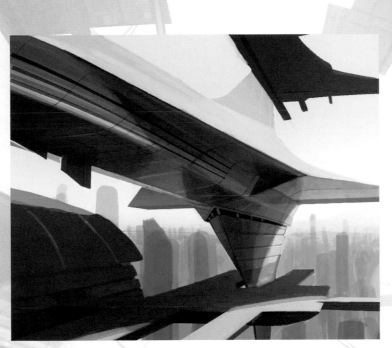

Step 7: Detailing the foreground

I've been adding more details to the craft while paying close attention to how the light will play off the superstructure. You might want to leave any intricate detailing until you have the light behaving correctly around the craft. However, adding some foundations for details, such as the three lines that follow the underside of the fuselage, can be useful guides for later detailing – these will be used for accommodation windows. I have started adding some livery colours to the craft too.

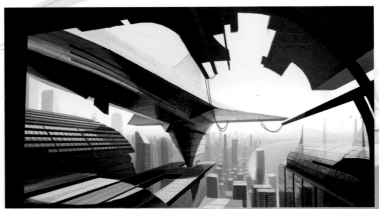

Step 9: Adding depth

Spend time focusing on the depth of the piece, which is one of the most important elements of an illustration like this. You will find it useful to emphasize the distance from the viewer to the ship and then to the rest of the scene by using silhouetted and sharp objects close-up and diffused shapes further away. You may have noticed that I have added somewhat to the canvas on the left – I want to frame this area with a section of silhouetted shapes.

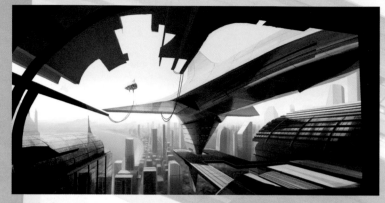

Step 10: Achieving compositional balance

You will notice that this image has been flipped. Images that have a challenging perspective or a complex composition can become difficult to balance; mirroring the image allows you to see it in a fresh way, bringing errors to light quickly. Try to do this often during the painting process, as it is very easy with digital media – traditional painters would have to use a large mirror to see the image in this way. I think the picture works well reversed, although it is evident that the large dark area is too big. Had I not flipped the image, this error may have escaped my attention.

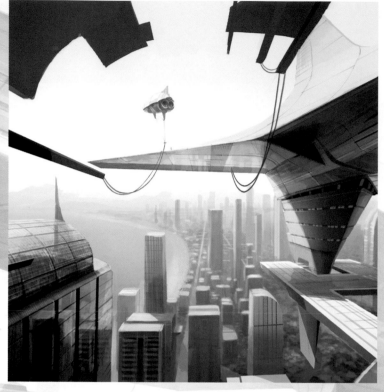

Step 11: Detailing the background

At this stage I tried to focus primarily on getting the feel right for the city in the background. I wanted to accentuate the nature-to-human balance and the clarity of the air, at the same time tweaking the craft's livery. It is worth experimenting with ideas while working up detail – you never know, they may work really well. The addition of a little ship tending to the cruiser adds some nice scale, along with a person on the wing guiding in the fuel lines from above. At this stage I have reviewed the lighting somewhat, intensifying the directional sunlight.

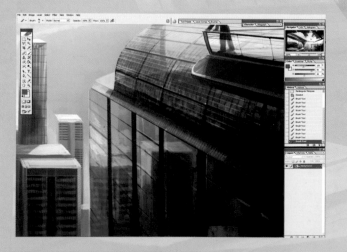

tip – Imply detail

When reflecting objects in water or mirrored surfaces, sometimes it is much more powerful to add distortion and inaccuracies to the reflected subjects. Here I have been very loose with the mirrored city, removing the sterile, too perfect, nature of a pure reflection, but have been tighter with the lines for the window frames.

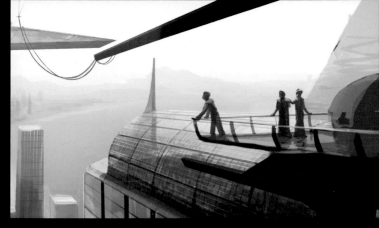

Step 13: Adding life

Try out ways to add life and realism to the scene, such as objects or people that are real-world in origin – these help describe the depth and scale of a piece. With this in mind, I have started to block in a viewing deck at the right of the image. It works well, but somehow it has highlighted the general dullness of the sunlit areas in the city and the further distance.

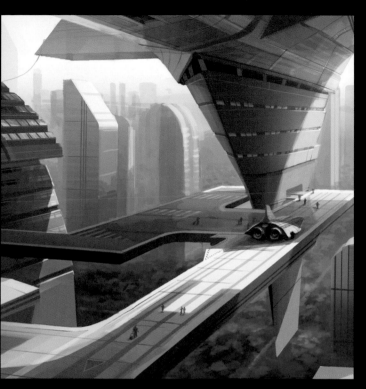

Step 12: Making changes can be good

The original terminal building annexe was not working. I liked what it was trying to do, but it was simply the wrong shape. You may find this happens during the creative process, but don't worry – just create a new layer and paint an alternative version on to it. I changed the shape so the terminal looks more like a landing platform opening out from the main building. I have added two other smaller craft, one to the left of the main craft similar to the refuelling ship, and another shuttle craft landed on the dock dropping people off. Finally here, I have decided to call the craft *Prometheus*.

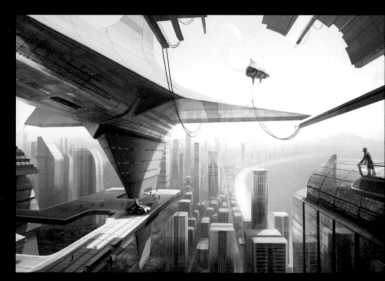

Step 14: Altering colour and other tweaks

To bring the brightness of the sunlit areas up, first choose a very large soft brush on a low Opacity setting and brush gently over the horizon using the Linear Dodge mode with a colour similar to the sky. Next, use the History brush to bring the closer elements back to a lower brightness; mainly it will be the back part of the craft that may have taken some unwanted brightness from the brushstrokes. Don't mask the area – it is better if you allow some soft bleed or bloom.

Step 15: Final image

As you get close to finishing the piece, lots of opportunities to add detail will start to appear. The question is, how long do you want to keep adding detail for? On an image like this, it could be a long time! I've worked up the people on the platform watching the boarding *Prometheus* and I'm quite happy with them. Try adding more detail to the surrounding buildings, more people on the dock, and anything else that takes your fancy. I have also added some red backlighting on the close-up refuelling assembly and some signs and symbols to the buildings in the city, but the choice of what to add is yours – you will know when there is enough detail. Finally, add your signature, flatten the image and save your finished painting.

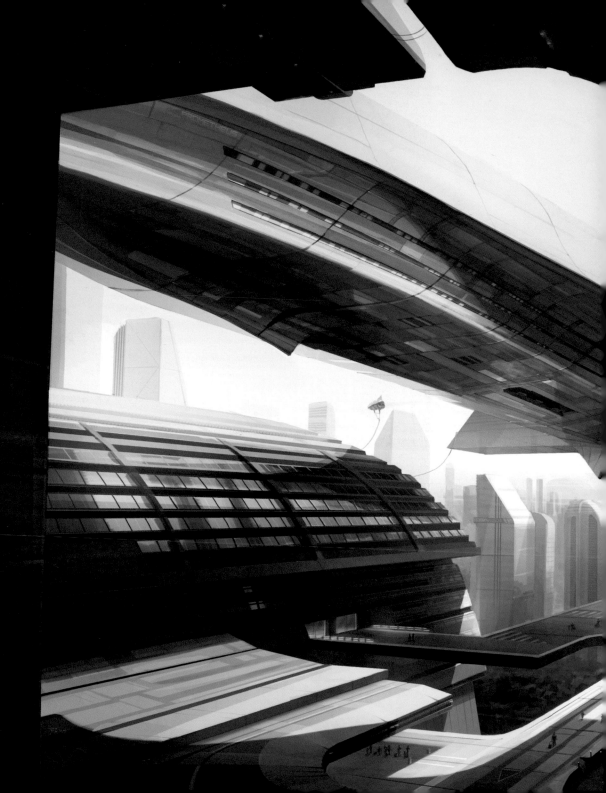

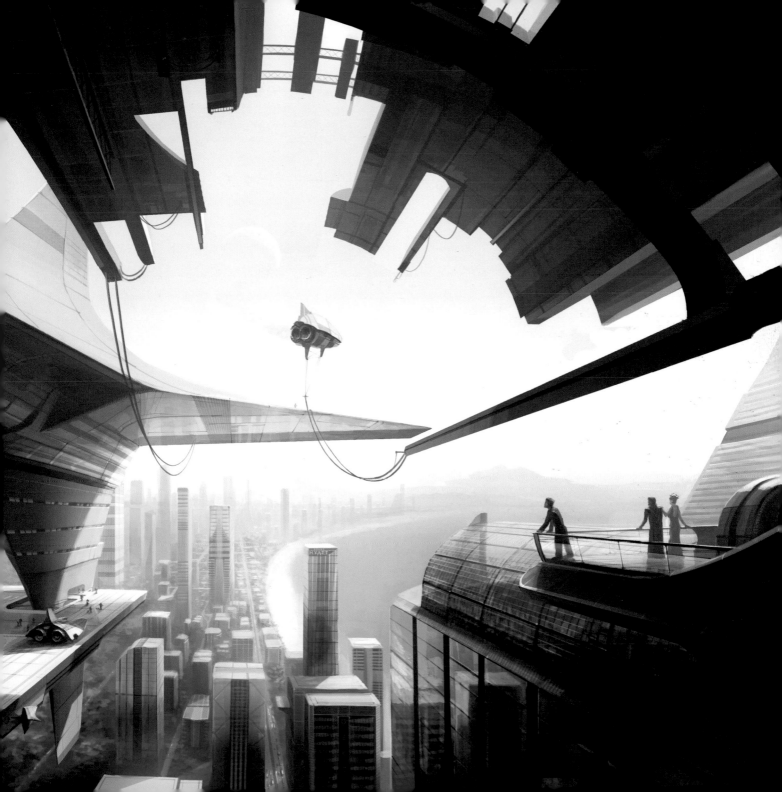

BRINGING A FANTASY LANDSCAPE TO LIFE

There is something wonderful about creating imagery that is representative of how our world is, but then adding some magical elements or amplifying the size of scene elements to create a more awe-inspiring vista. This piece is intended to illustrate these fundamentals, to give the viewer the impression that they are here, on Earth, but somehow in a more mystical and amazing past or future where magical things are possible.

Step 1: Sketching out the idea

Very roughly, sketch out what you would like the image to depict and what elements are going to be most important. This piece will embrace a lush and sunlit land in the midst of an enormous dark and evocative volcanic mountain range. I have used simple brushstrokes, using white and black in Photoshop. At this stage don't get hung up on details – just get the rough composition right.

Step 2: Shaping up the focal point

Start painting using loose colour washes on top of the existing line drawing (or if you like you can just start by washing colour down without any line drawing, as I often do). Quickly you can see what the intended focal point will be – this volcano is going to dwarf anything in the sunlit land so what I am doing here is forming the shape of it. Once the rough volcano is in place you will get a good impression of what is going to be needed to help frame this enormous form.

Step 3: Balancing the composition

As you can see, the volcano is overpowering the image somewhat. To counter this, and to give the image substantial depth and scale, I have started to add some close-up elements to the sides of the piece. These will frame the image, helping lead the eye from where the viewer is, across the green fields, past a settlement in the middle distance, and ultimately into the darkness of the volcano's shadow. I also want to add a feeling of darkness behind the viewer, to give the impression that this land is a haven surrounded by less pleasant places.

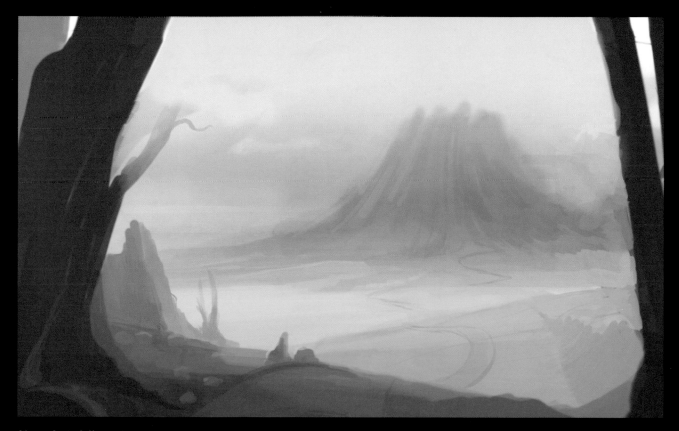

Step 4: Adding depth

With an image of this kind it is necessary to establish a neat balance between tiny elements and enormous structures or features. This piece is going to require a flowing view that leads away from the viewer's standpoint; for this I have started adding a path that will lead out of the foreground forested area to the settlement. This path also adds a vital element of scale to the piece.

Step 5: Simulating atmospheric diffusion

As you work up the composition, try to increase the depth of the far distance by diffusing the colours, bringing the saturation levels towards grey and generally dropping the contrast away. Try using a large, soft grey brush on normal setting to paint back the distant objects from the more distinct near features. Be careful not to go too far; you are gently implying distance here, not fog. This is very much an area for attention to detail.

Step 6: Framing and adding further depth

In this piece, the framing is a delicate process of tempering the edges of the image with darker features, but only enough to draw the eye towards the focal point at the centre of the piece. Adding frame-creating close-up shapes can substantially increase the believable depth of a painting. Notice that I have also altered the brightness of the sky immediately behind the upper branches. This helps to punctuate the shapes without having to use a very dark colour for them. Try out some alternatives by painting the branches on to a separate layer and then altering the sky behind them until you find a pleasing contrast.

Step 7: Resolving perspective

For this piece I am using some vertical perspective lines to engineer a leaning frame from the up-close fauna. You do not really need to use these lines to do this, but if you are unsure about how to balance any effect like this, perspective lines can be very useful for generating smooth transformations from the sides of the image. The blue (Y) lines are not used for the other parts of the image, but the red (Z) lines are, to help control the depth from viewer to settlement all the way to the focal point of the volcano.

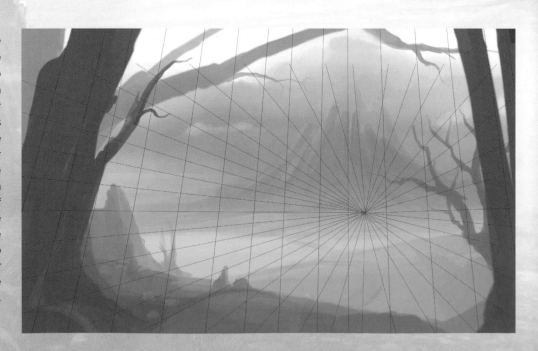

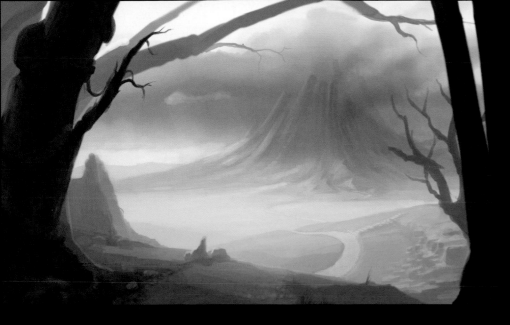

Step 8: Using light and shadow

Paramount to generating the right sort of depth for a piece like this is the use of light and shadow. What you may find challenging in this particular piece is the requirement to have a dark and foreboding area in the distance and also close-up, leaving just the middle ground basking in direct sunlight. Here I have added to the vibrancy of the lit area, to help distinguish it from the volcanic area behind. Alongside this, try fleshing out some details that help define the distances between the forest and the volcano; in this case I have continued working on the footpath that leads away towards the soon-to-be-painted settlement. Also, use this time to remove details that aren't working, like the straggly tree on the right.

Step 9: Controlling tonal balance

You may find that as you work up the contrast between sunlit, diffuse and dark areas of the image, a good tonal balance is difficult to achieve. As a guideline, try keeping the balance of roughly 60 per cent of one, 25 per cent of another and 15 per cent of another between bright, medium and dark tones. You can mix and match these values as you wish.

Step 10: Adding the settlement

Crucial to the ambience of this piece is having a human-like settlement nestled between the two ominous areas of deep forest and volcanic activity. It is also important to try to convey that although this town is dwarfed by the surrounding natural features, it is indeed a home to many. I've added a fortress-like wall around the perimeter, giving the impression that the inhabitants have to deal with frequent attacks from the surrounding areas. The position of the settlement also makes a statement about its inhabitants – good guys, surrounded by pesky monsters.

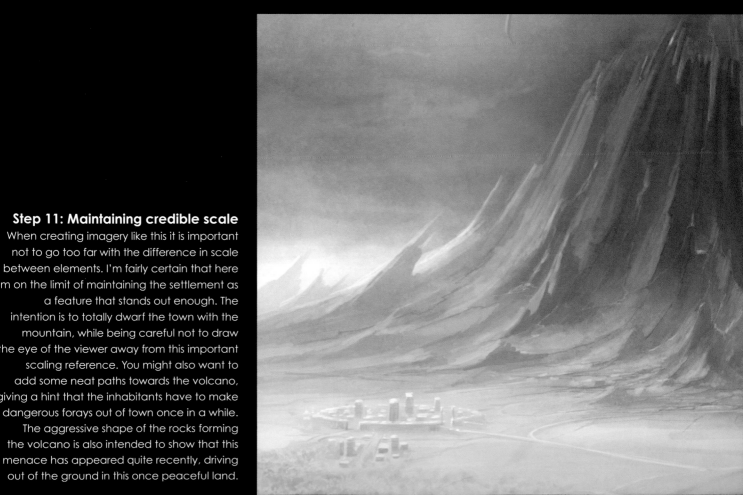

Step 11: Maintaining credible scale

When creating imagery like this it is important not to go too far with the difference in scale between elements. I'm fairly certain that here I'm on the limit of maintaining the settlement as a feature that stands out enough. The intention is to totally dwarf the town with the mountain, while being careful not to draw the eye of the viewer away from this important scaling reference. You might also want to add some neat paths towards the volcano, giving a hint that the inhabitants have to make dangerous forays out of town once in a while. The aggressive shape of the rocks forming the volcano is also intended to show that this menace has appeared quite recently, driving out of the ground in this once peaceful land.

Step 12: Detailing the volcano

To get the most out of the volcano's shape you will want to move in close and start working up some nice detailing to help underline the sharp shapes and hard nature of this structure compared to the surrounding natural areas. Start using smallish brushstrokes with a hard brush to add highlights to the rock textures – be careful to get the balance right as the volcano is essentially in diffused light (under the clouds). Then add some softer dark tones to emphasize the height of these jutting rocks. Finally, add some veins of light red, showing lava bursting out and running down the mountain.

Step 13: Framing considerations

The way you frame an image like this can greatly affect the way people read it. What I have tried to do with the natural shapes up-close is give the impression that the viewer has just come out of a deep forest and is being greeted by the vista of a homely place to stay, but is also made aware of the ominous threat beyond it. With this in mind, try being subtle with the tones on any natural features not directly in front of the viewer. Dropping the colouring so it accentuates the lit area helps the forest melt away and draws the eye towards the focal point smoothly. You may have noticed the use of a few blurred leaves too; these can be fun to paint when you want to add depth, but too many here would have cluttered the vista.

Step 14: Adding foreground detail

The backbone of the framing for this piece is the trees, most notably the one to the left. This shape and its surrounding elements are fundamental to drawing the viewer's eye out of the darkened frame and into the main part of the image. You might want to try out some interesting colour combinations in these elements. I've chosen to use a complementary red colour for the leaves and creeping shapes around the tree. This creates a lovely contrast with the greens in the mid-distance and also helps describe the dramatic change you are implying with the forest behind the viewer. Other little details such as rocks, grass and shadows all operate to reinforce the feeling of darkness up-close.

Step 15: Final image

Viewing the image as a whole, you are able to see how the careful balancing of scene elements and framing has constructed a vista that contains depth, drama and a tinge of threat. The use of shadows and trees to frame the image helps hold the eye in the right place, while the path walks the viewer into the mid-distance where they arrive at the settlement, only to be overwhelmed by the growing volcanic citadel that is consuming the landscape. I have also been working with the tones around the mountains, using a very subtle Linear Burn brush to darken the clouds and mountain slightly to give it that extra edge and to pin the settlement dramatically in light. The wide gamut of colours and saturation used helps to amplify the distinction between 'good and evil'; I have slightly desaturated the darker areas while bathing the lighter parts in rich colour. You could continue to add details or even people to this piece, but I think it is well balanced as it is, so sign, flatten and save your painting.

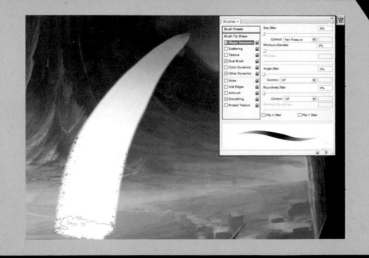

tip – Choosing the right brushes

Think carefully about what brush detail you want when you are laying down strokes. I have used a 'standard' brush here, which gives a sharp, rough edge and size inconstancy between X and Y directions. Importantly, I have altered the brush settings to make the brush react in scale and opacity depending on how firmly the stroke is laid down on the tablet.

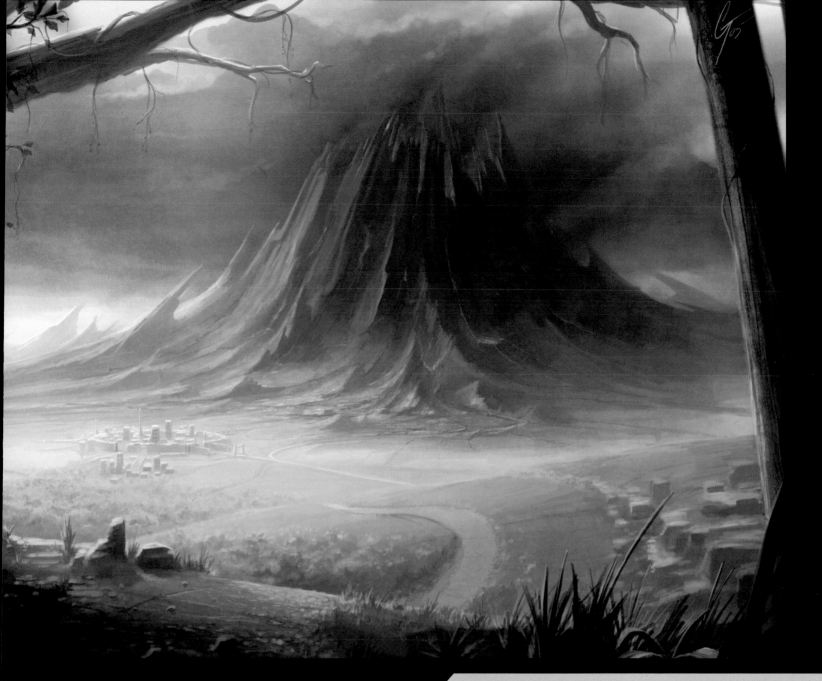

tip – Creating peaks of light

Even if part of the subject is in diffuse light or shadow, it is worthwhile helping to underline its surface and shape with careful use of highlights or soft light reflection from lit areas. By doing this you can help draw details of objects out further in the image and imply more detail in the darker or silhouetted part facing the viewer.

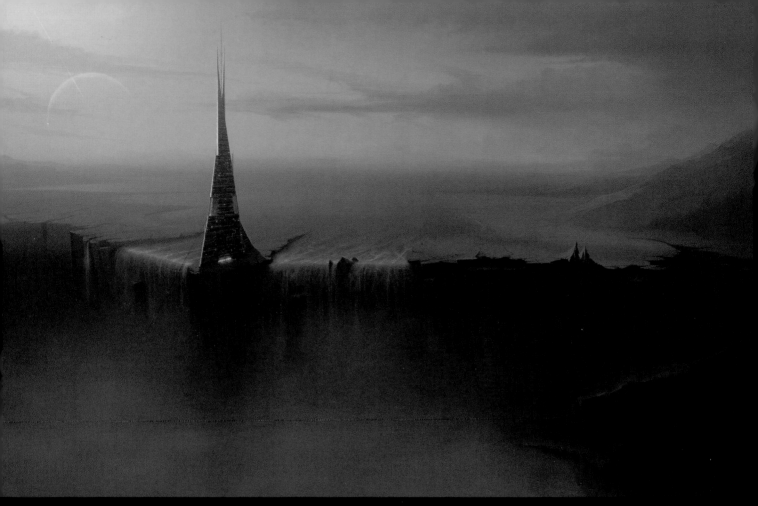

SENTINEL A dramatic structure astride a waterfall in a fantasy world

Structures and Vehicles

When examined in the context of the infinite size of the universe, human achievement is dwarfed by the inexplicable magnitude of nature itself. However, there is something incredible about humankind: created from nature and then in turn being able to engineer and construct amazing devices and structures to use in our environment. From the ancient pyramids and cities of early civilization, to the possibility of highly evolved beings in the millions of far-flung galaxies, the options for painting exciting buildings, bridges, vehicles, contraptions and spacecraft are endless.

I find it very uplifting to hypothesize about what we humans might create in the future, or what might already be out there somewhere, waiting for us to discover. Delve deep into your imagination and think, what would you build today if you could make *anything*?

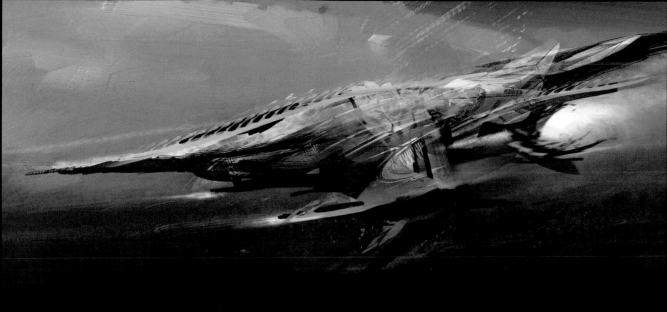

FLIGHT RESPONSE A very dramatic image from master painter Philip Straub.

BUILDING A STRUCTURE WITH SCALE AND DRAMA

Majestic, immense buildings that pierce the sky or fill your vision are very powerful vistas for digital painting. I love imagining that beings, whether on this world or others, can create structures so remarkable that they defy the laws of engineering and physics as we understand them today. Alongside this, I always try to illustrate these incredible constructions harmoniously within the surrounding environment; this is not about dominating nature, but rather understanding it enough to make building anything possible.

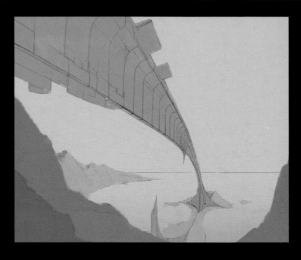

Step 1: Starting off

For a piece like this, be very aware of the dramatic impact the focal point will make on the composition. Think carefully about how you might want to portray the main feature, as it is going to become the strongest element of the image. Try a few quick rough thumbnail sketches to start with. Once you are happy, create a higher-quality line drawing, as I have here. Notice that I have created my perspective lines here too – the accuracy of perspective is paramount in a piece like this. Draw the perspective lines on a separate layer using the Line tool, then drop the Opacity of the line layer to about 40% and lock it, (so that you do not accidentally paint on it).

Step 2: Adding a colour wash

Once you have the main body of the shapes in place and you are happy with the way the perspective is working, add a colour wash over the image to show the silhouettes and lighter areas. You will find this a good way of finalizing the composition and ensuring that the focal point is not too overpowering. You might want to paint the wash for the actual structure on to a separate layer, so that you can hide it and work on the sky behind the structure more easily.

tip – Lead the eye

Think carefully about the kind of 'visual movement' you are looking to generate for the viewer's eye within the piece. Here, the main structure leads the eye right into the heart of the image. Then the other parts of the composition help to hold their gaze gently within the framing elements, which are the natural features of the hills and the yet-to-be-added clouds.

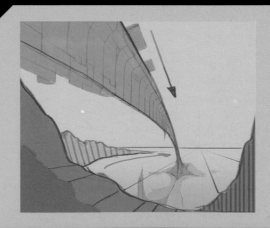

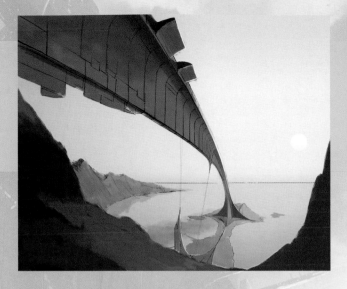

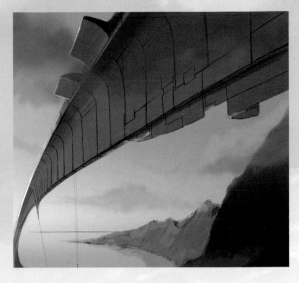

Step 3: Placing the light source

This is a very important stage. The enormous shape is going to dominate the piece, so try to complement its position with the placement of the sun. The sun's position will allow you to choose to play with reflected light to show a polished arch, or to dull-light the structure to pierce the shape out from the sky. I also brushed some slight colour washes to the sky while adding the light source.

Step 4: Checking the composition

Here I have flipped the image – make sure you do this often to keep a check on the composition. While the image is flipped try adding some detail to the arch; try to use lines and details that help add more structural justification and perspective foundations. You will find that you add different details when the image is flipped – and this is a good thing.

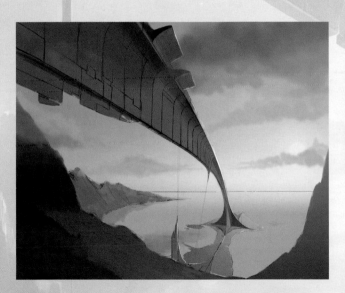

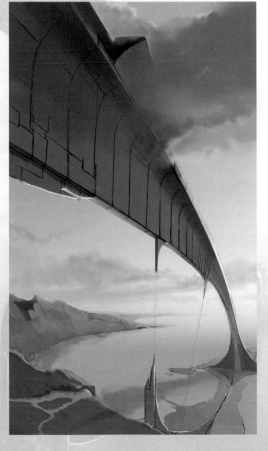

Step 6: Integrating the structure into the environment

For me, this piece hinges on the graceful integration of an enormous manmade structure into an idyllic natural environment. You want to help merge the object into the world around it with the subtle use of atmospheric effects such as dew or haze and the general colour closeness objects take on in the distance. As the structure falls away, it takes on much of the tonal and colour values of the surrounding landscape.

Step 5: Blocking in some features

Large blocks of colour are a good way to help you contour the composition into shape. The clouds are an important part of this piece, so start blocking them in on a new layer. This will help balance the top of the image and give a good impression of the final look.

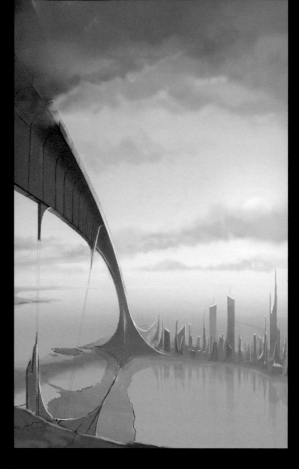

Step 7: Generating atmosphere

Here, using the clouds as a perfect contrivance, blend the shape of the structure into and through them. This will give a very definite position for the arch, both in the distance and in the nearer areas. These subtle effects anchor the shape into the piece effectively and help the viewer to understand the image.

Step 8: Framing considerations

You may have noticed earlier that there was an implied shape of a steep hill to the right of the piece. I had placed this as I was sure I would need something to help frame the image in this area. After some consideration, however, I decided to add a city falling away into the distance. Try some different ideas and see what you prefer, but bear in mind how important the framing of a piece like this is.

tip – Working with Opacity

When working up the cloud layer, drop the Opacity of the other layers so you can see exactly how the cloud layer is behaving. Here, none of the clouds are at 100% Opacity, but have been painted to complement the surrounding sky and structure. Painting clouds like this takes a little practice, so try a few types on different layers until you are happy.

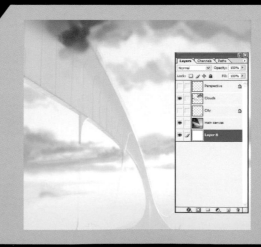

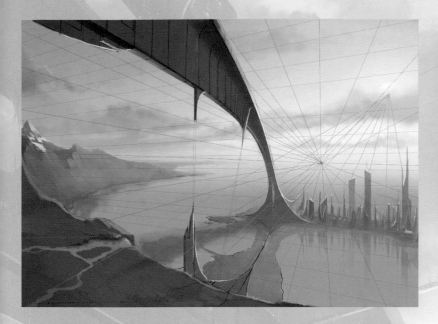

Step 9: Adding light effects

Here, I have added some green radial lines to demonstrate the direction of the sunlight for this piece. Even if you are employing a fairly diffuse light, as I am in this scene (the sunlight hits distant clouds and scatters to an extent), you could still try using the odd sharper shadow to help solidify the structure into the piece further.

Step 10: Making changes

I was not happy with the shape of the mountains – they were too real-world for the image – so I radically changed them to a style I am much more content with. Don't be afraid to play with shapes and ideas during a piece; just create a new layer and paint away, and you might find a great new way to represent something. I have also been adding details to the ground nearest the viewer, mainly helping the perspective along with some use of little tributary streams and botanicals.

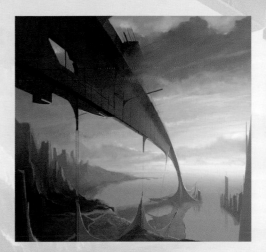

Step 11: Colouring the image

At this stage I have flattened all the active layers and then proceeded to do a couple of colour washes and colour filters to punch it out more. I will leave a final Brightness/Contrast pass until the end, which I tend to do just to settle the piece once all the elements are in place. You might want to play around with the colouring of the piece at this point, perhaps warming or cooling the colours; the pink tones in this piece are a challenge, but I wanted this look.

Step 12: Detailing the structure

Adding detail to the structure is the first opportunity to show just how large this object is. You might want to use liveries or add complex window arrangements to the structure, but I thought it would be great to just add staggered lights and windows, many of which are quite small, which gives a sense of the arch's enormous scale. Be careful when laying out the details and lights that they complement the shape you have so carefully engineered. With this arch you could continue to add details and effects for some time, making it look like a far more extravagant shape. My feeling was that a shape as epic as this would hardly need to shout its presence with dressings – its sheer existence is awesome enough, so I kept the detailing down to a more rudimentary level.

Step 13: Emphasizing scale

Work more at integrating the structure with the environment and the surrounding elements. Much of the success of this piece will be judged on how well-knit together these disparate elements are. Intrinsic to meshing the different elements together is giving the arch a scale reference. By creating a (relatively) real-world city at the base of the structure, you give the viewer a sense of the grand scale. Also by painting these sorts of details you can help give the image a flavour of realism – important when the subject matter is as extreme as this.

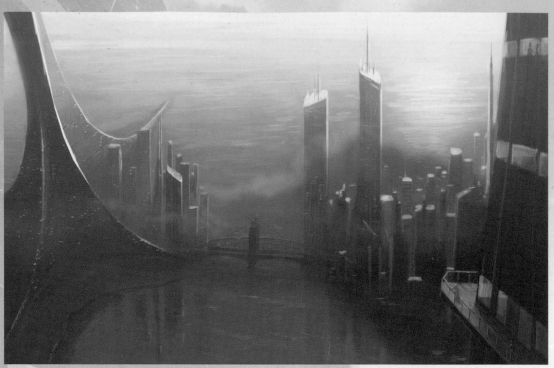

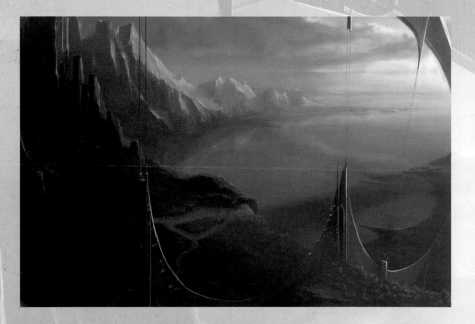

Step 14: Adding further ground detailing

Building up the ground detail is an important part to solidifying the myriad of elements in this scene. I have been adding extra detailing to the streams and botanicals on the plateau beneath the arch, while also creating some features for the ancillary stabilizing structures that spear out of the ground towards the arch. Try gently adding light and atmospheric diffusion to the ground areas at the base of the piece. This will help to underline to the viewer how far away it is, even though it is much closer than the arch base.

Step 15: Including small 'human' elements

Think about what other human-type elements you would like to add to the piece to emphasize life, movement and scale. Placing a couple of craft in an image like this can be a great way of making it come alive. You can also help describe a deep image by having the odd vehicle moving into or out of the image. These were drawn on to a separate layer so they could be position- and scale-altered to ensure they complemented the other elements just right. Always try to paint tertiary elements such as these on a new layer so you can adjust them without heavy repainting on the main piece.

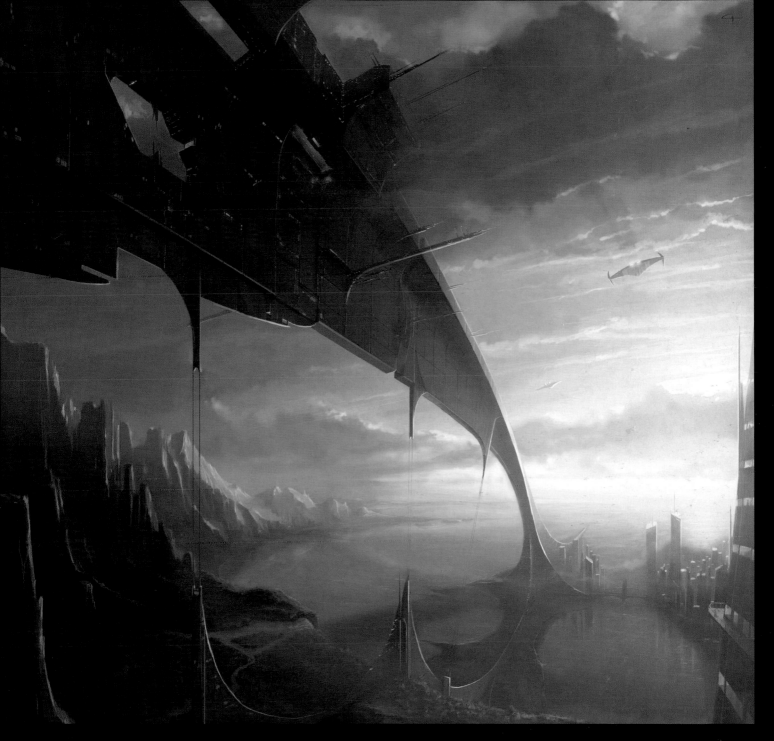

Step 16: Final image

Looking at the final piece, it is evident how carefully the composition had to be balanced to achieve cohesion of shapes, effective
depth and believability. Much hangs on how well you portray the main structure – this arch is immensely powerful, but careful
use of light, shadow and other landscape features help keep it in check. Try rotating this book 180 degrees and have a look at
the piece upside down, or get a mirror and look at it reflected; you can see how powerful the shape is when it is flipped in an
unfamiliar direction. The last part of my time is spent adding details to a variety of areas – adding a person on the balcony on the
building to the right, more diffusion using a variety of brush modes and other gentle brushstrokes to balance everything. Again, you
could add detail to this for a long time, but when you are ready, flatten, sign and save it, and sit back and fall into the piece.

ILLUSTRATING A FAST-MOVING VEHICLE

I like vehicles with a sense of purpose – either very big or very fast. In real life, these would be the magnificent Concorde supersonic passenger plane, or the lithe yet menacing lines of a Lamborghini supercar. In the fantasy realm, the possibilities for what can be painted are endless: spectacular giant rolling vehicles, flying craft or gravity-defying super-destroyers can all be at the tip of your brush. Contemporary vehicle design, whether real or fictional, borrows much from nature, specifically from animals and insects.

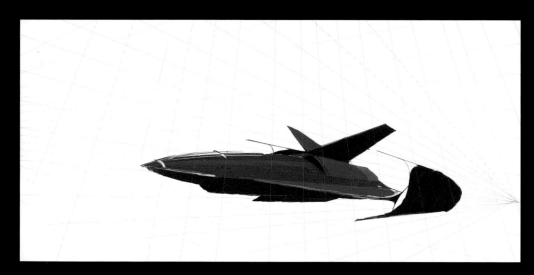

Step 1: Starting off

Creating a vehicle design can be a fairly iterative process, with many sketches being created before you start the full illustration. This can be time-consuming, so for the purposes of this demonstration, let's imagine you have been working on some ideas for a craft and are relatively happy with one design. If you know how you want to project the vehicle, lay down some perspective lines to work with; if not, sketch the vehicle out raw and then construct your perceptive lines after you have done this. You can fix any problems with the shape when you have the lines in place.

Step 2: Checking and colouring the shape

After playing around with the shapes, try flipping the image to decide which way you prefer the composition to fall. Doing this early on will allow you to see whether there are any odd bits in the shape (which I can see now, but will attend to later). Then, on a separate layer, paint a wash over the sketch to solidify it. You can then see where the lighting might be striking the bodywork. I've added some simple shadows and dark and light areas to help punch out the shape.

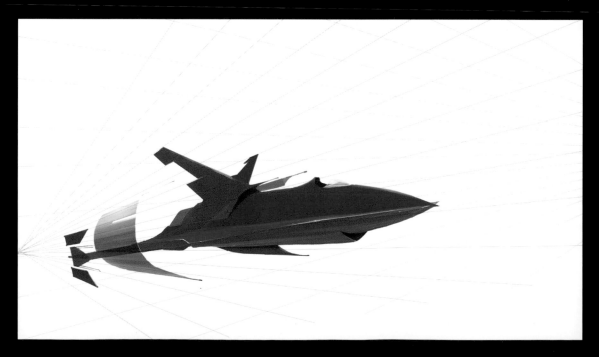

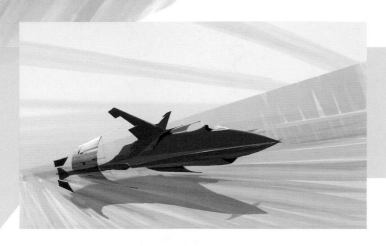

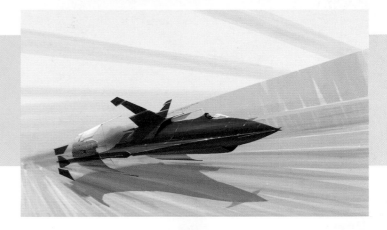

Step 3: Adding a simple background

On the background layer, paint in some loose washes of colour. Notice that the brushstrokes I have used are very loose and blurred – while you will want the craft to be sharp and detailed, lowering the detail on the background will greatly increase the impact of the vehicle. The intention here was to situate the craft in a desert setting, and when painting the underside of the craft I added some accents of light brown reflected light.

Step 4: Developing material properties

When you have a decent balance between subject and background you can start working on the bodywork to help punch out the shapes, taking into account that the vehicle is going to be shiny in appearance. Developing reflections and shiny effects is something that many people find difficult. The key is to remember that loosely implied reflections and nicely placed highlights are there to help define the shape of the craft as much as show what is reflected, so bear this in mind when working on these.

Step 5: Implying speed

I've done a couple of colour washes on the background to help bring it out more, while also adding details to the mid- and far distance. By doing this you will be able to show that, while the craft is moving very fast, the objects in the distance are quite a way off, being less blurred. Try adding some other swooping lines, using the perspective grid as an aid, to help you imply more movement. Do not draw over the main craft; instead, paint these effects on to a separate layer.

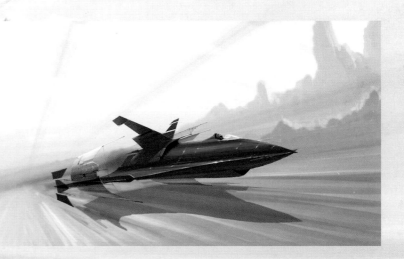

tip – Adding movement blur

Try using the Radial Blur tool to add a sense of movement to your scene. Very roughly paint some near-ground shapes on to a new layer and then select the Radial Blur mode. Within the Blur dialog box, move the centre of the blur to the point the vehicle is coming from and set the mode to Zoom. Adjust the Amount to suit and hit OK. This will give you a nice rough pass to work over in finer detail later.

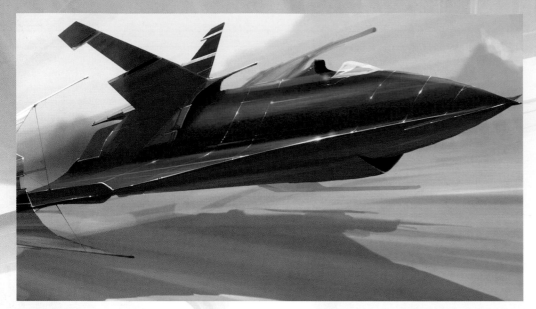

Step 6: Detailing and fixing errors

If you look carefully, I have shifted the rear solar wing on the craft as it was badly placed in the original sketch (this became evident when I laid out the perspective lines; see step 2). Don't feel that you should have every detail right straight away – worrying too much could have an adverse effect on the flow of your art. Just acknowledge that there are problems and work on them as you see fit. While you are up close, work up some more details on the vehicle.

Step 7: Fixing the composition

At this point it can be useful to start thinking about how you want the final composition to work. I am becoming happier with the main craft and the feeling of movement. Try adding another craft up close to the viewer. This has a dual purpose: you can use it to show some great close-up details, so the viewer can understand how the vehicle is made and translate that into the main craft, which is too small to show the details. More importantly, it is also a very useful framing tool for the image. The angle of the close-up craft helps add drama and movement to the piece, as if it is passing over the viewer's head.

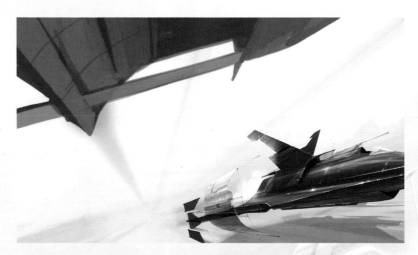

Step 8: Being selective with detail

The high level of detail does not need to encompass the entire piece. Deliberately leaving areas of lower or looser detail can help draw the viewer's eye towards the features you want them to look at. Keep in mind that 'loose' does not mean 'badly painted'; there still has to be harmony. The less detailed areas should help bring the more important parts of the image to the fore, without corrupting the rest of the piece.

Step 9: Tweaking colour

I have flattened the image here; dropping the vehicle and effects layers on to the background canvas allows you to do a gentle colour filter pass to bring the elements further together. I used Color Balance for this – adding a touch more red and yellow to the image. You might want to add a visible light source at some point too. As you can see, I've placed the sun at the top of the image, adding a little more realism to the way the vehicle liveries are behaving in the light. Note I've also added the tail of another craft, to the right, for compositional balance.

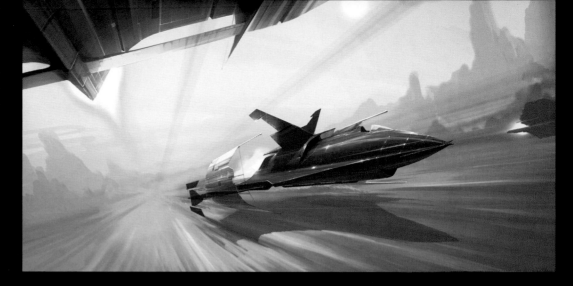

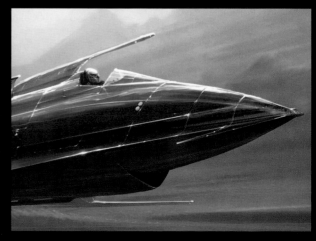

Step 10: Adding general detail

The image is slowly evolving from a study of a single vehicle into a high-speed race between ground-skimming craft, which is great. Working some details into the piece can be very enjoyable, such as the craft in the mid-distance. Once you have overcome many of the shape issues and compositional challenges it can be a nice break to sit there for a couple of hours adding little nuances that bring the subjects to life. Interestingly, this piece is quite clean and tight for my normal style, so it suits these additional details well.

Step 11: Increasing close-up detail

Moving in closer, work some details into the fuselage of the main craft – little things like the fuelling ports, the gills on the wings and the areas where the perfect paint has been stripped away by the enormous velocity of the race. Fine details like this can really bring an image to life, and be nice surprises for the viewer who takes the time to look carefully at the piece. Notice also how the very detailed ship is in harmony with the low-detail, motion-blurred background.

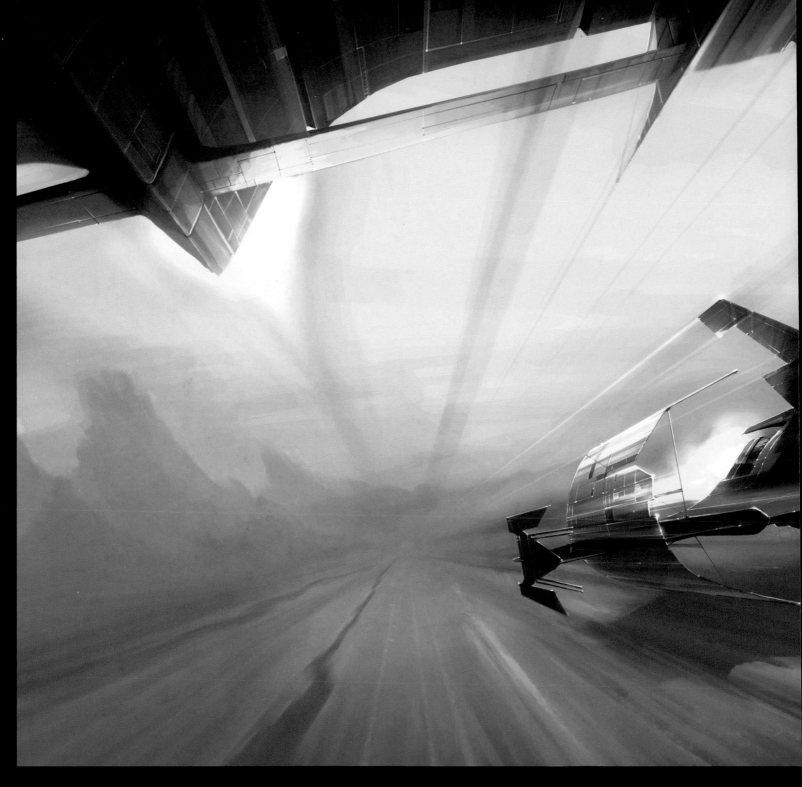

Step 12: Final image

To finish off the piece I did a simple Brightness/Contrast pass to help punch out the dynamic range of the image. Try adding final touches of dust speed lines and highlights until you are happy that the image works as a whole, then sign it and save it.

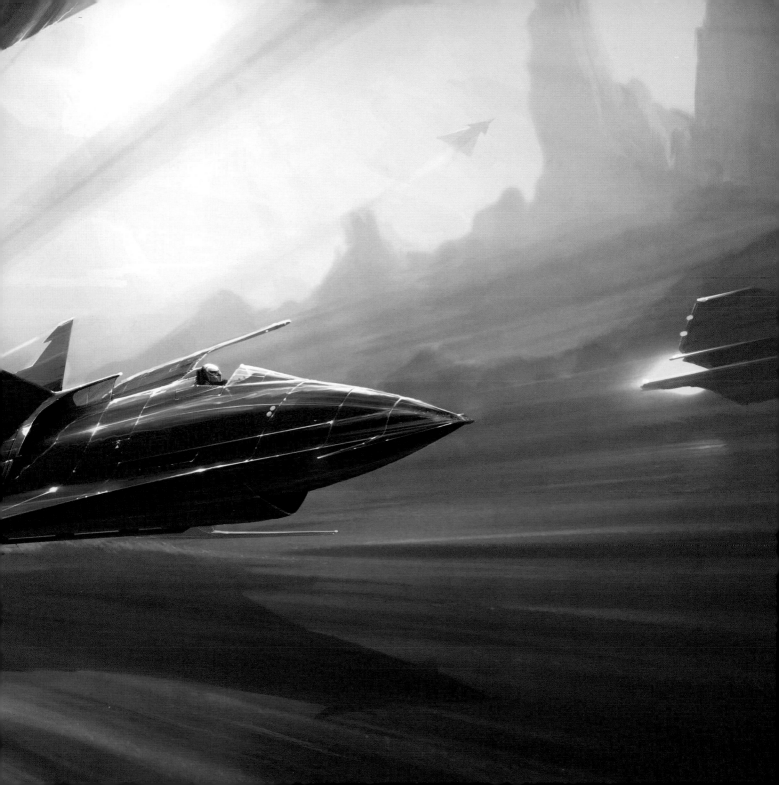

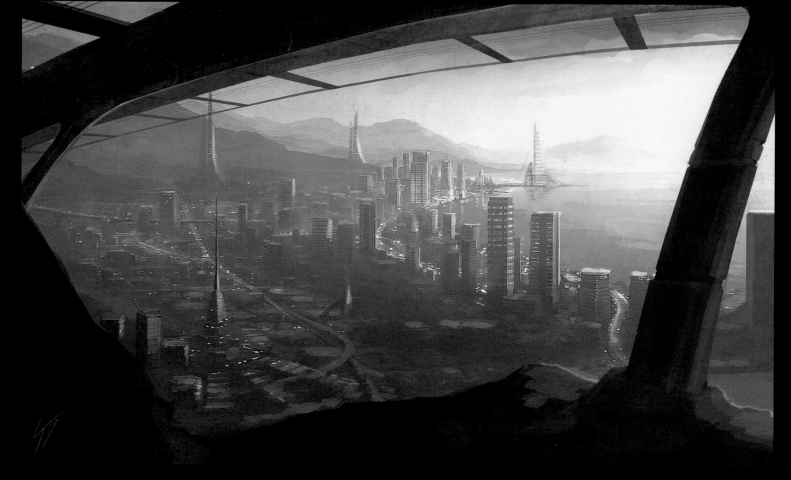

FUTURE CITY This 90-minute speed painting of a futuristic cityscape was posted on the Deviant Art website, receiving over 40 pages of feedback from fellow site-users.

What to Do with Your Art

Once you have a body of work that you are proud of, what's next? One of the joys of working in the digital age is the incredible ability to make copies of your work and display it in a myriad of arenas, potentially exposing your art to millions of people. This has opened the art world wide open, and you no longer have to be famous or even have to an agent to get your work seen.

growing to enormous sizes and becoming repositories for the very best digital art you can find on the Internet. Many artists have found clients and a full-time profession simply from having an Internet portfolio – word of mouth has done the rest. This is exactly what I have done with my own freelance work: I have been working as a professional games artist for 20 years, but I found a new level of exposure and inspiration by posting my work online, from which I have been able to broaden my horizons in the art field, something that would have been very difficult 15 years ago.

Online art communities are very useful for increasing your profile as an artist and also for getting critiques on any work you place on them. If you are keen on getting feedback on your work, I would recommend setting up accounts on these types of sites – you may well learn a lot and be inspired by other artists' work too.

RECOMMENDED ONLINE ART COMMUNITIES

www.cgsociety.org
CGSociety is an excellent hub to visit if you are looking for inspiration in your art, to learn new techniques or even find yourself a commission or a new job. A lot of professionals use this site as a place to convene and discuss all things art, and many companies scout this network for talented individuals for new projects. CGSociety also has a publishing wing of its own, producing some beautiful books on many facets of art. I was fortunate enough to win a couple of awards in their *Exposé* series of books.

www.deviantart.com
Deviant Art is simply an enormous web community where all possible forms of digital (and non-digital) art come together. The highly eclectic nature of the art content is stunning, and many obscure content pages can be found on here, but the site is well maintained and is an excellent place to set up a page.

www.gfxartist.com
GFXArtist was one of the first sites to notice my work and post some of it up on its 'art of the day' page. I received a lot of attention from this and quickly decided to join the community. Although in recent times the submissions to the forums are weighted more towards photography than digital painting, this site does offer a great breadth of quality work and friendly people.

CREATING YOUR OWN INTERNET PORTFOLIO

When you get to the point of having a number of digital paintings you are proud of, this is the time to create a personal web gallery to show off what you have created, which anybody with Internet access can view. You may find that it takes a while to get a large number of people hitting your site, but that will come from word of mouth and by posting on the community and art sites and forums across the web (see pages 120–21). Importantly, try to make your site as easy to read and navigate as possible. Design the look to complement your work, but try not to over-embellish things to the point that your art becomes secondary. I recently changed my VisionAfar.com site so it was much easier to move through and update; previously it was Flash animation-based, which caused me a lot of headaches with compatibility and other issues. Most professional artists keep their site complexity down to help clients get to what they need easily.

If you build up friendships with other artists on the forums you might be able to create a network of people you share links with. Linking to each other is a great way of networking your art, plus you never know who might pop in to have a look – a new client, a movie company, anybody!

GENERAL PRESENTATION RULES

The temptation to 'advertise' your art with a flashy and high-impact site is strong. After all, you want people to see what you have to offer. But trust me, when you want to show how good you are at painting your art, ensure that you also show that you know how to *present* it. A clean and simple site will make it very easy for a visitor to find their way around and get to the good stuff – your art. You never know, Steven Spielberg could visit, and wouldn't it be a tragedy if he were turned away before getting to your art by a badly designed site?

If you are looking to present your work online, try to remember this paramount rule: your art is the focus, not the canvas it is painted on, so keep the site clean and unobtrusive.

Presentation is all when you are looking to impress people with your art. Try picking a few images you are really proud of and have them appear randomly on the front page, giving a different flavour to the site each time it is entered.

Make sure people know where they are when they arrive – nothing is worse when landing on a site than the confusion of not knowing what you are looking at.

Look at this modified upper bar: the large wide area has a Flash animation playing in it, moving through a few of my pieces. Notice, however, how shallow the area is, thereby keeping the visual intrusion down.

You want to excite and intrigue the viewer with the thumbnails you have in your gallery pages. Tantalize the visitor with an expertly cropped area of the piece that makes them 'need' to click on it to see more.

Keep your navigational tools visible whenever you can, such as the immediate click tools that take you to another part of the site and the forward and back arrows to skip through the images.

When you click on a thumbnail, ensure that the individual image page complements the piece and does not in anyway overrun or draw your eye away from the piece.

OTHER WAYS TO GAIN EXPOSURE AS AN ARTIST

If you desire to become a professional artist, the good news is that there have never been as many and as diverse career opportunities for an artist as there are today. Much of this has come about because of the digital art age. Television, movies, illustration and computer games companies all now use digital art to create their visions, so you can learn your craft on your personal PC and know that the skills you acquire will be usable in the modern creative environment.

MAKING A HARDCOPY PORTFOLIO

If you are really serious about getting your work under the right noses in the industry, it is worth thinking about creating a hardcopy portfolio in addition to your online one, and having a run of copies printed that you could send out to prospective companies and clients. This can be a little on the expensive side, especially as you need to ensure that the final printed media is of good quality and excellent colour reproduction, but it will certainly get you noticed. Importantly, you must be vigilant with your portfolio and only include the very best 15–20 images maximum. You want to show clients what you are capable of, and any weaker images will detract from the impact of the portfolio. Your hardcopy portfolio should signpost people to your online portfolio for further examples of your work and more information about the artist.

ORGANIZING EXHIBITIONS

Another way of getting noticed is to arrange an exhibition of your work. Galleries are often interested in the work of local artists, and your online or hardcopy portfolio could help you to secure some wall space. Obviously this will entail printing your work at large-scale reproductions, which can be expensive, but this might be recouped if you manage to sell any pieces. Galleries usually take a small percentage of any sales, so make sure you factor this in to your asking prices, as well as your overheads, without pricing yourself out of the market. Even if you do not make any direct sales, you may still find that an exhibition is a good way of gaining exposure and opening doors into the wider industry.

ATTENDING TRADE EVENTS

If, like me, you find yourself in a niche where you want to target your artistic endeavours and publicity at a distinct demographic, going to art trade shows and showing your work, either by having your own stand, or simply just by taking a portfolio around to show any prospective companies, can be highly worthwhile. You can find details of worldwide trade events online.

Magazines such as *Imagine FX* are a great way to get exposure and can also be used to show other art lovers how you create you work.

SUBMITTING WORK TO MAGAZINES

There are many dedicated publications such as magazines and digital art annuals that are open to having new works submitted to them for print. This can be a great way of getting excellent exposure, not only to other artists and the general public, but also to professional clients and companies that might take a shine to your work. Browse the newsstands and search online to find any publications that might be suitable for your style of art.

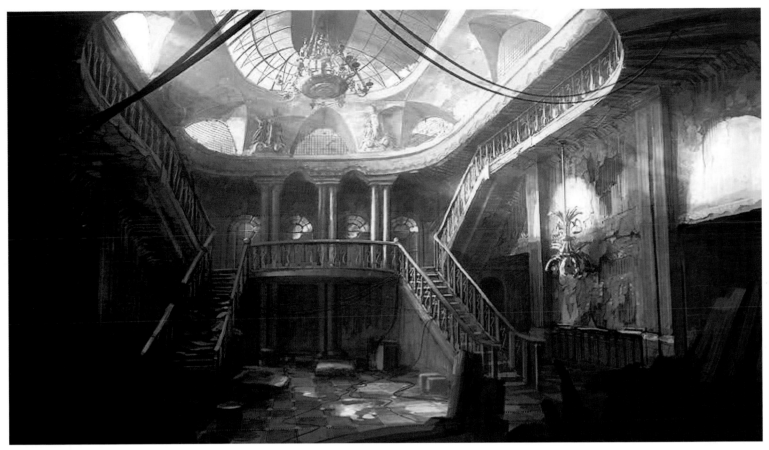

DISUSED COLONIAL THEATRE This image is a concept piece for a high-profile Xbox 360 game, but could just as easily be part of a large-budget movie project or a TV-series set design.

GAMES AND MOVIES – INTO THE FUTURE

When I started out in the games industry in 1987, computers were extremely crude when compared to the systems most people have in their homes today. The graphic capabilities were very limited, sometimes down to as little as two or four colours on screen at the same time. The graphics I worked on in those days were very different from what you might have seen in the cinema or on television. However, in the last five years or so, the quality of high-end computer game art and of movie work is practically the same. Many of the packages used to create art (Maya and Photoshop, for example) are used in both industries. Indeed, I know a number of artists who flit from movies to games and back again while freelancing. This goes for pretty much any type of art that uses computers in the process; the technology is drawing all digital artists together, towards an enormous community, where we can all learn, teach and inspire one another. I am very excited about where things might be going in the next decade and beyond, with so many people working at creating incredible visions for the future. I look forward to seeing what you create...

INDEX

ACKNOWLEDGMENTS

I would like to give my heartfelt thanks to the following people, in no particular order – you all know what you have done for me.

My beautiful daughter Catherine, who lights up my life with love and happiness – everything is worth while because of you. My Mum for having faith in me from the very start, standing by me while I chose to be 'arty' in the face of conventional thinking, and for countless other things through my life. My Dad for understanding, and for believing that I could become the artist I am. My brother Craig, for being there and keeping my feet on the ground, reminding me what is really important in this world. Vicky, Craig's lovely wife and my sister-in-law, you rock! My fantastic nephews Jacob and Lewis, you make the world go round – and shake (Lewis)! Michelle, you are wonderful and amazing, I love every part of you fiercely. Lisa Perry – creative genius and brilliant mother to Catherine, get well soon and thank you for the use of some of your beautiful photos. Andy Speirs – Rock on Mr Space! David Percival – you need to keep painting! Adam and Gail Karran – I will miss you guys. Darren Wakeman and Sarah – I owe you both. Chris Rocks – you certainly do buddy! James Farnhill – fab boy. Paul, Lisa and Reese, Paul and Ruth, Joe Flores-Watson and Chris Smith – thanks for being there and being true friends. Andy Norman – Mr cool. Carl Entwistle – old friend. Thanks to Neil, Kerry and Andrew Topham, Mike, Judy and Emily Smith, Anne and Tim and James Bonsor. And of course God, for giving us our lives to lead in this utterly beautiful Universal creation. Sometimes fantastic, at times hard, occasionally difficult to live, but always, in these first tumultuous years of our eternal existence, an incredible experience.

My creative friends and inspirations of whom there are many: Kev Crossely – you rule brother. Philip Straub – genius. Linda Bergkvist – your vision of this world is amazing, never stop what you do! Natascha Röösli – amazing art. Fergus Duggen – 'paint more or answer to me pal!' Susanne Sexton – you crazy chick, luv ya! Graham Gallagher – you too! Ady Smith – stay creative brother. Roberto Cirrillo – massive talent. Liam Kemp – oh my! Greg Martin and Paul Walker – stay cool man. 'Disney' Dave Pate – miss you buddy. Mark Donald – miss you too man. Andrew Wright – thanks for that pencil sketch dude! John McCambridge and Christian 'Tigaer' Hecker – keep creating man! Paul Vodi – AKA 'Darkmatterzone' – photographic mastermind and great inspiration. Michel Bowes – mild-mannered superhero and friend. Steve Wakeman – top boy. Mike Monaghan – AKA 'MMM', John Payne, Wayne Dalton and Herod Gianni – miss you guys. B.E.Johnson and Joy Day – amazing artists – thank you for the break guys. Thanks to Rich Morton, Phil Chapman, Daryl Clewlow, Andy Gibson, Jerry Oldrieve, Gerard Miley, Simon Reed, John Haywood, Christian Russell, Matt Charlesworth, Trevor Williams, Gavin Rummery, Alan Sawdon, Andy Sandham, Roger Mitchell, Carl Tilley, Dan Scott, Alison Bond, Colin Rushby, Henning Ludvigsen, Ryan Church, Syd Mead, Iain Mccaig, Raphael-Lacoste, Craig Mullins, Yanick Dusseault, Eric Tiemens, CGSociety.org, Deviantart.com, GFXArtist.com, Digitalart.com, CgChannel.com and 3DTotal.com. To every single artist of any kind that has inspired me and all the people that have contacted me over the years to tell me what my art means to them – your energy and appreciation reminds me what art is about and keeps me inspired to keep creating, THANK YOU.

PICTURE CREDITS

ABOUT THE AUTHOR

Gary Tonge is one of the UK's foremost concept designers with over 20 years experience as a digital artist. His work spans greatly from being a full time Art Director and a freelance concept artist/illustrator, where his work is represented under the banner of www.visionafar.com. His client base is as diverse as his art and includes the BBC, Vivendi, Capcom, Eidos, The Urantia Foundation, Sims Snowboards and The National Geographic. He is a regular contributor to *Imagine FX* magazine and lives in Warwickshire, England.